USA
BEIJING 08

6/7/10

Hi,

Having no reason to keep two
books on Chelsea, I'm returning
yours. It's also another reason
to use some good stamps. Please
return them all. It was good
seeing you again.

Love,
Tony

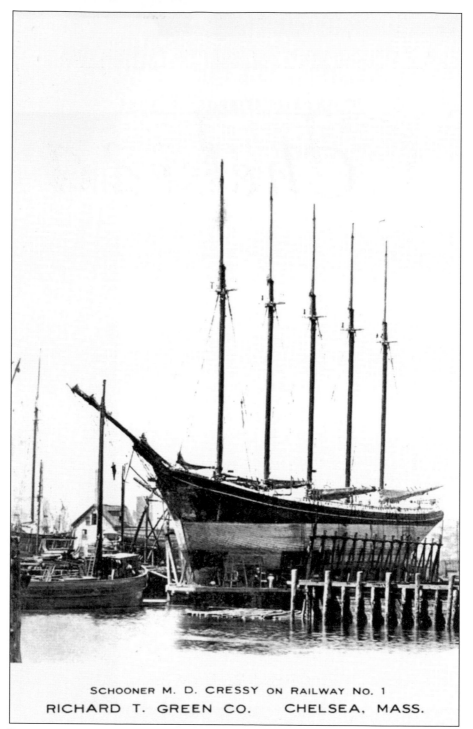

SCHOONER M. D. CRESSY ON RAILWAY NO. 1
RICHARD T. GREEN CO.    CHELSEA, MASS.

THE SCHOONER *M. D. CRESSY*. In this nicely composed *c.* 1909 view, a five-master undergoes maintenance at R. T. Green and Company. The firm was located at 208 Marginal Street in Chelsea. A number of shipbuilding and ship repair facilities stood along the waterfront (Williams and Marginal Streets); however, postcard scenes of the industry are scarce.

POSTCARD HISTORY SERIES

# *Chelsea*

Gerard W. Brown

ARCADIA

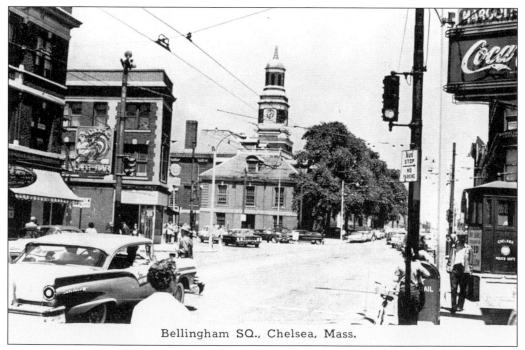

Bellingham SQ., Chelsea, Mass.

**BELLINGHAM SQUARE.** Looking up Broadway toward city hall, this *c.* 1961 action view of downtown shows the city's traffic control booth on the right. The booth accommodated one policeman and was in service until *c.* 1965. Above the sign for Coca Cola is one for Margolis's Drugstore, which is still in business today. Note the row of mature trees in front of city hall, breaking up the harsh city landscape.

# CONTENTS

# ACKNOWLEDGMENTS

This book is the compilation of more than 25 years of effort. Many people have helped me achieve this goal. First and foremost, I would never have been interested in collecting and preserving history if it were not for my great-grandmother Sarah (Wilcox) Cater and my grandmother Christine (Cater) Carroll. Both recounted to me, in great detail, their childhoods in Chelsea. In fact, Sarah told me of her successful escape from a burning home in the 1908 fire. I miss them both. Likewise, George Morley, a family friend, was instrumental in getting me started in the mid-1970s by sharing his recollections and photographs of life in the early 20th century. I would also like to thank Nicholas Minadakis, who hired me at the Chelsea Public Library in 1974. My time spent there in the archives helped nurture a growing interest. By 1977, I was a true collector of local history and spent the next two and a half decades searching for postcards and stereoviews. Along the way, I met a number of people who shared their passion for local and regional history, including the following: Victor and Carol Casaburi, Tony Gurliacchio, Peter McCauley, and Irving Chirande. Special thanks also go to George Ostler and my father, Weldon Brown, for supplying historical text for this volume. Both men's keen interest in documenting Chelsea history helped make this book possible. Also, thanks to Robert Collins and George Athas of the Chelsea Public Library, who made me feel at home in the expanded archives room. I must also mention bookseller Lisa Bouchard, who encouraged me to produce this history. Finally, I am grateful to my family, who helped support writing the book.

# INTRODUCTION

This book is an illustrated history of Chelsea, Massachusetts, from 1867 to 1962. These years encompass the popularity of the stereoview (a three-dimensional photograph) in documenting 19th-century life to that of the chrome postcard, which recorded the mid–20th century and beyond. The city is fortunate to have had a number of historians detail Chelsea's history, including Gillespie (1898), Chamberlain (1908), Pratt (1908 and 1930), and, more recently, Clarke (1998). The author's main purpose in compiling this volume is to document for future generations historical information amassed since the 1970s. In addition, this book will hopefully be used as a reference from which to build.

The images were selected from a collection of more than 300 postcards and stereoviews. The oldest view dates from 1867. It is one of 25 stereoviews included from the late 1860s to the mid-1870s. Chelsea had just emerged from the Civil War and was in transition from an agrarian way of life to an industrial and commercial center. Spurred on by the Industrial Revolution, many businesses located in Chelsea along Marginal Street, Eastern Avenue, Pearl Street, and Williams Street. This growth required a work force to labor in the factories and businesses; therefore, many immigrants moved to the city. The included photographs from the period do not record this influx of people. Instead, they focus on daily events in the hub of the city—Broadway Square—and its environs. The images are historic. They record some of the remaining undeveloped areas, including the western end and Powderhorn Hill, and the city's last vestiges of a summer resort—the Highland Park Hotel.

The period from 1875 to 1900 was not represented in this book because few photographic images were made during this era and, of the ones that were produced, few survive.

The 20th century coincided with the advent of the picture postcard. This event resulted in the photographing of literally hundreds of Chelsea images. During the first decade, many different views were made of the Chelsea Ferry, the Marine and Naval Hospital, the Soldiers' Home, Chelsea Square, many of the churches, business and residential streets, schools, and public buildings. It is apparent that the people who purchased and sent the postcards were very civic-minded in their choices of what was photographed.

As the first decade moved toward the end, a devastating fire wiped out residential and business sections of the city. The April 12, 1908, disaster was due in part to the uncontrolled growth of junkyards in the city. Unfortunately, this practice did not stop. Chelsea blossomed as a leader in the scrap-metals business in the decades after the fire. Consequently, history repeated itself 65 years later, when the October 1973 fire wiped out 18 city blocks.

The reconstruction period (1908–1912) and after was an optimistic time for the city. Following the fire, Chelsea rebuilt its infrastructure of streets, churches, schools (Williams and Shurtleff), public buildings (the library, city stables, and city hall), and businesses. Many of these achievements were recorded in photo postcards.

The years from 1910 to the 1920s saw a decrease in the diversity of views produced. However,

the exceptions were dramatic. One New York photographer recorded a virtual pictorial history of the Marine and Naval Hospital complex. His effort has given us an accurate portrait of the post–World War I years. The images also record important historic sites that highlight the city's beginnings in 1624.

The city's historic Prattville section, with roots tracing back to the 1600s, played a vital role during the American Revolution. Although few postcards were published of Prattville, the existing views give a decent portrait of this residential neighborhood spanning more than 50 years, from 1905 to 1962.

The Soldiers' Home was located in a historic area of the city. American soldiers were quartered on Powderhorn Hill during the American Revolution years. Building a veterans' home on the highest point in the city made the site a perfect location for photographing images. As a result, the Soldiers' Home and vicinity are well documented in postcard images during the 20th century.

The 1930s and 1940s through the 1960s saw a scarcity of postcard views, in part due to the Depression, World War II, and the hard economic times of the postwar years. Nonetheless, two important photographers worked the streets of the city, recording the years from 1950 to the early 1960s. The views are important, as they document some places in the city not typically photographed, including the Mystic River Bridge and Union Park.

In closing, the author has attempted to select the most interesting and appealing images for this book. This comprehensive volume reflects many years of collecting. It is by no means complete. Surely, some areas of the city have been omitted. That is not intentional but due to an absence of images. The author wonders why there are so few photographs of synagogues, or no views of the African Methodist Church, Mill Hill, or the Cary School. It is hoped that, with persistent searching, we will uncover more treasures that will help us better understand our past.

# One

# THE 19TH CENTURY
# IN STEREOVIEWS

Several Massachusetts photographers produced stereoviews of Chelsea. Stereoviews are two essentially identical photographs mounted side by side, which, when viewed through a stereoscope, result in a three-dimensional image. Stereoviews were manufactured primarily from the 1850s to the 1930s, as the popularity of postcards during the early 20th century and the Great Depression ultimately resulted in the demise of the art form. Over a 25-year period, the author has amassed a small collection of local stereoviews. Although incomplete, the selection is an invaluable snapshot of Chelsea history from the late 1860s to the mid-1870s.

Oliver F. Baxter was the most prolific of all Chelsea stereo photographers. A resident of the city from c. 1868 to 1876, he moved his photographic studio to three different locations during this period: 138 Broadway (1868), 147 Broadway (1870), and 198 Broadway (1872 and 1876). His whereabouts in 1874 are unknown. By 1878, Baxter had moved his business to 517 Washington Street in Boston. Based on an actual examination of views and directory listings, he worked early on with another photographer named Eliot Adams. Very little is known about Adams. Records show that he moved to Gloucester in 1878. Baxter's photographic production, however, is well documented. He produced at least 25 views of Chelsea and neighboring towns. Most of his output centered on views of Broadway (Chelsea) Square and its vicinity, prominent churches, the Naval and Marine Hospital, and the Woodlawn Cemetery. Baxter may also have had some business dealings with another local photography studio, B. & B. F. Sargent. No known local views by the Sargent are known.

R. E. Lord and Shaw & Lord of 51 Washington Street, Boston, produced the stereoview series Boston & Vicinity and Cambridge. A small number of views of Powderhorn Hill, Chelsea, and the local area were also published, c. 1873.

A few additional Chelsea stereoviews were produced; unfortunately, most do not give credit to photographer or publisher. Several panoramas were photographed from the top of the Bunker Hill Monument, some of which show the Naval Hospital and waterfront. One of the better-known series was Boston & Suburbs, America Illustrated, likely published by Charles Pollock in the early 1870s.

The invention of photography approximately 30 years before had paved the way for these men to ply their trade and document history. Their effort has given us a window to the 19th century.

**A STEREOVIEW BACKLIST OF O. F. BAXTER.** This full-sized label, *c.* 1870, was primarily used on the back of O. F. Baxter's issued views. It is very informative, listing his complete stereoview output. In fact, every Baxter view in the author's collection has been cross-referenced to this series. The backlist also indicates that Baxter traveled outside Chelsea and produced photographs of neighboring Saugus and Winthrop to finish his First Series set.

**B. & B. F. SARGENT AND O. F. BAXTER STEREOVIEW LABELS.** This *c.* 1870 double-label suggests a business connection between photographers B. & B. F. Sargent and O. F. Baxter. The Sargent photographic business was located in Green's Block, at Broadway and Second Street. Built in 1869, Green's Block was a prominent three-story building that housed Chelsea's first free library, businesses, offices, and residential apartments. It was named for James S. Green, a successful businessman who had previously owned a livery stable at the same location for 16 years.

THE WATER CELEBRATION IN
BROADWAY SQUARE. O. F. Baxter
and Eliot Adams took this wonderful
view on Thursday, November 21,
1867. The Water Celebration was a
result of the successful completion of
a clean-water connection between
Chelsea and the Mystic Lakes in
Medford. The celebration was
appropriately centered around the
new drinking fountain in Broadway
Square, on the present site of
Columbus Park.

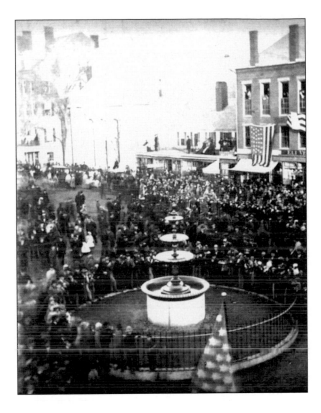

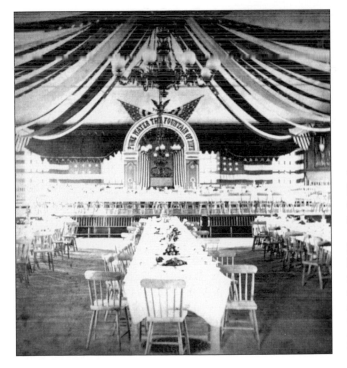

THE OLD CITY HALL
INTERIOR, THE WATER
CELEBRATION. This rare Baxter
and Adams view was taken c.
1867 inside the original city hall,
located on Central Avenue near
Shurtleff Street. Most other
images show only the building's
exterior. Note the number of
flags in the room. The citizens of
Chelsea proudly display their
patriotism at this event, only two
years after the Civil War ended.

11

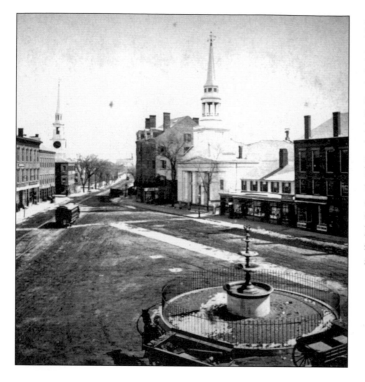

**BROADWAY SQUARE, WINTER.** Looking up Broadway, this well-composed O. F. Baxter view was taken from an upper-story window or roof, given the camera perspective. Baxter shot this negative in winter; recently fallen snow can be seen around the newly built drinking fountain. To the right is the white steeple of the Broadway Congregational Church. The lack of people in the view suggests it is early morning or a day of rest.

**BROADWAY SQUARE, C. 1870.** This winter view looks southward down Broadway. The drinking fountain, prominently pictured in several Baxter views, is visible in the left center. The main building in the image is where Baxter took his panoramic Broadway Square stereoviews. By the 1890s, many of these buildings had become history, as the building of the Winnisimmet Parkway altered Chelsea Square permanently.

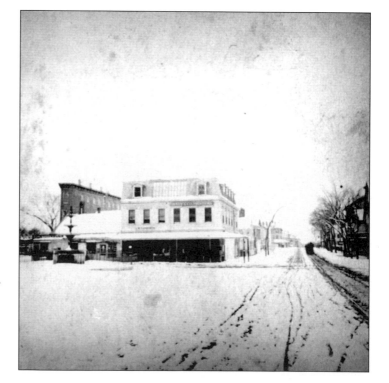

**BROADWAY SQUARE, JULY 4, 1868.** In this scene of a well-attended Fourth of July celebration, the First Baptist Church is located just to the left of the spouting fountain. Behind the crowd, to the right, is the Broadway Congregational Church. This early Baxter image is a nice example of a well-documented stereoview, in which the photographer, date, and location are identified on the back label.

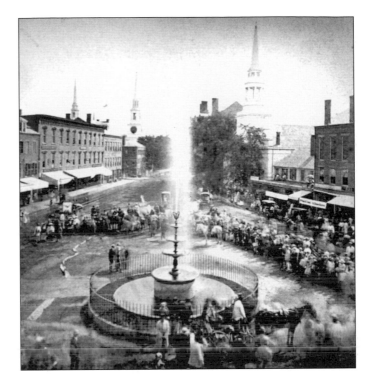

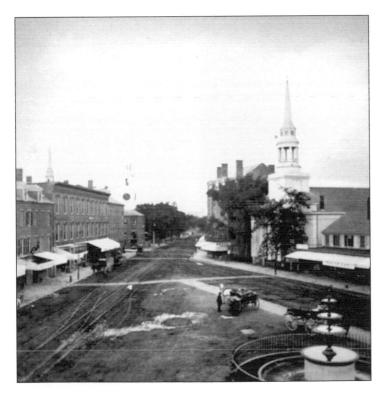

**BROADWAY SQUARE, SUMMER.** Taken from the same location as the previous winter view, this Baxter image shows summer well under way, as evidenced by leaf-filled trees and fully engaged building awnings. In the days before air conditioning, the awnings were necessary for keeping people shaded from the summer sun. In the background, to the left, the First Baptist Church can be seen, at Broadway and Third Street.

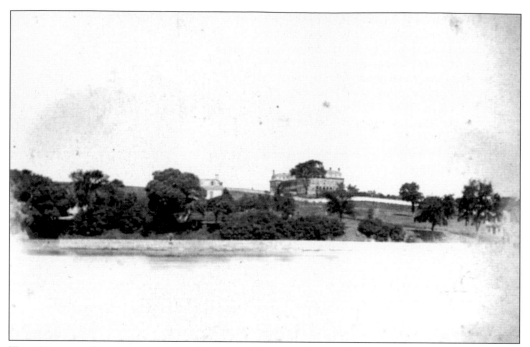

**THE MARINE HOSPITAL, FROM CHELSEA BRIDGE.** A partial view of the U.S. government grounds is seen in this *c.* 1870 Baxter view. The red-brick Marine Hospital, built in 1859, is located in the center. The familiar mansard roof was added a couple of years later, in 1866. To the left of the Marine Hospital, a corner of the commandant's residence can be seen, partially obscured by trees.

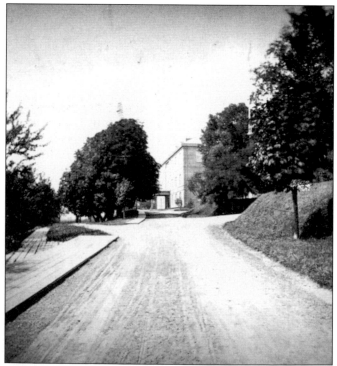

**THE NAVAL HOSPITAL ENTRANCE.** This Baxter view looks up the main drive toward the Naval Hospital building (constructed in 1836 and expanded in 1865). The main portico can be seen over the front entrance. To the left and below the building is a wide-planked wooden walkway. These early sidewalks were a necessity in the days before paved roads. The mature trees around the building are in full leaf, indicating a late-spring or summer photograph.

**A POINTER POSING.** The significance of the posed photograph is unknown. In this view, the dog wears a necktie of some sort. Since pointers are known for their keen hunting skills, was this Baxter's hunting companion who would accompany him on trips to the nearby Rumney (Revere) Marsh? We may never know the answer, but this First Series stereoview addition is one of Baxter's more intriguing images.

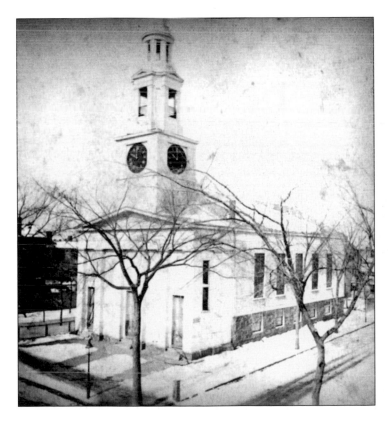

**THE FIRST BAPTIST CHURCH.** Located at Third Street and Broadway, this church was organized in 1836 and the building erected in 1837, making it Chelsea's first church within city limits. An 1850 Chelsea directory lists James N. Sykes as pastor and Ralph Beatley as sexton. The nicely composed image captures the architectural beauty of this early Chelsea church, which no longer stands.

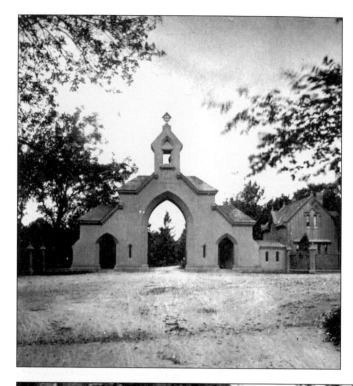

**THE WOODLAWN CEMETERY ENTRANCE.** The original Gothic-Revival gatehouse and lodge of the Woodlawn Cemetery are pictured in this *c.* 1870 Baxter view, taken at the junction of Woodlawn Avenue and Elm Street in Everett. The gatehouse, built *c.* 1850, served as the main entrance for more than 40 years before being torn down in the 1890s. A new gatehouse and lodge were built in the late 1890s and still exist to this day.

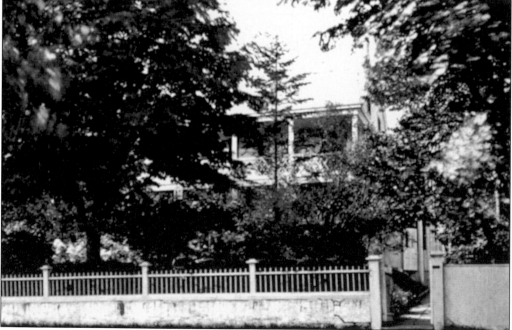

**THE RESIDENCE OF FRANK B. FAY.** The home of Chelsea's first mayor was located on Chestnut Street near Beacon. The period manuscript on the back states that the lot was situated one removed from the Naval Hospital grounds. Fay (1793–1876) also served the city as president of the Chelsea Savings Bank and as agent of the Chelsea Ferry and Land Company. His son Frank Ball Fay also served as mayor during the early Civil War years.

**CHELSEA AND BOSTON, FROM HIGHLAND PARK.** This panoramic view by R. E. Lord was taken from the summit of Powderhorn Hill, facing Boston. The Cary Avenue Methodist Church steeple is visible on the left. A horse-drawn trolley in Cary Square travels on Washington Avenue toward Broadway. On the right is a *c.* 1870 mansard-roofed building that housed Engine 2. To the right is the *c.* 1868 Carter School. Both buildings were located on Vogel (now Forsyth) Street.

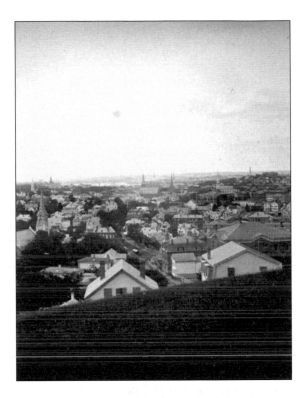

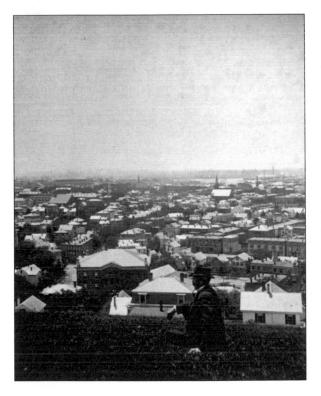

**CHELSEA AND BOSTON, FROM HIGHLAND PARK.** Similar to the previous one, this *c.* 1875 R. E. Lord panoramic view reflects a right shift in camera position. The Carter School is prominent in the lower left center. Built in 1868, the four-story building served as a coeducational grammar school for a number of years. The structure survived until 1917, when it was replaced by a more modern school building. The name remained the same.

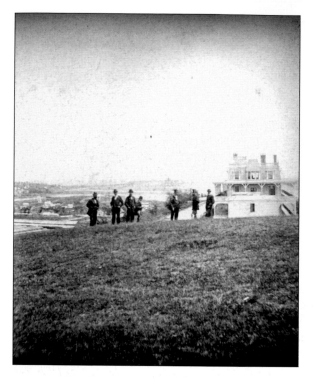

**THE HIGHLAND PARK HOTEL.** In this Shaw & Lord side view, taken atop Powderhorn Hill facing Revere, a number of distinguished-looking gentlemen can be seen. The group may be the owner(s) and board of directors of the hotel. The hotel, which opened in 1873, was only in business for a few years. The building was later sold to a Civil War veterans' group and was remodeled into a hospital called the Soldiers' Home.

**CHELSEA, EAST BOSTON, AND CHARLESTOWN.** This panoramic image by R. E. Lord most likely shows the southeast waterfront of Chelsea from East Boston. The Meridian Street Bridge occupies the left background, and Bellingham Hill appears on the extreme right. The first naval battle of the American Revolution took place near this location in 1775, when colonists burned the schooner *Diana,* abandoned by British troops.

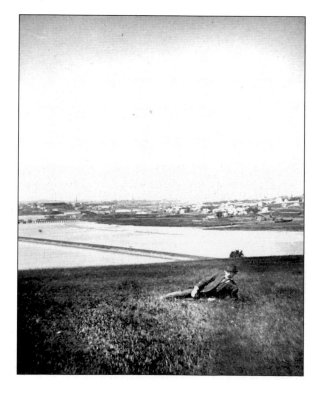

**A VIEW OF CHELSEA.**
R. E. Lord paired up with another photographer, Shaw, to produce this panorama. The view was also taken from the summit of Powderhorn Hill facing Naval Hospital Hill and Boston. The man standing in the foreground also appears in one of the previous images. Spruce Street is clearly visible on the right as it runs toward Williams Street and the hospital grounds. This image shows how few houses the western end of the city had in the 1870s.

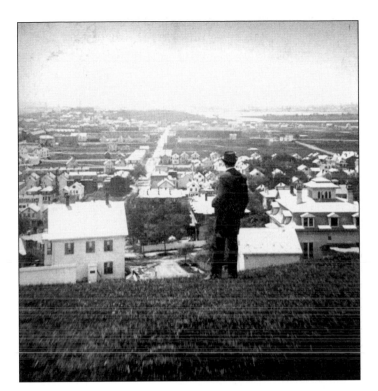

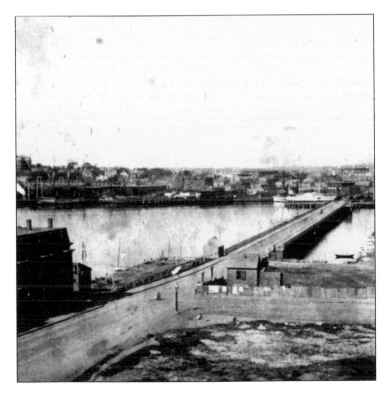

**CHELSEA, FROM EAST BOSTON.** The Meridian Street Bridge, originally constructed in 1855, connected Meridian Street in East Boston and Pearl Street in Chelsea. This view shows the bridge *c.* 1874. At the extreme left on the horizon, part of the Marine Hospital building can be seen. Chelsea's waterfront was very active when this image was taken, as seen by the number of sailboats and steamships moored on the Chelsea side of the bridge.

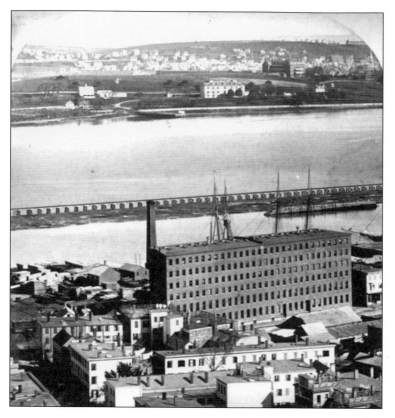

**A VIEW FROM THE BUNKER HILL MONUMENT.** This *c.* 1874 panoramic view of the hospital grounds, across the Mystic River in Chelsea, shows the Naval Hospital in the center distance and the Marine Hospital in the right distance. On June 17, 1775, the citizens of Chelsea witnessed the Battle of Bunker Hill from the summit of Naval Hospital Hill. Behind the Marine Hospital building appears a mostly undeveloped Powderhorn Hill and part of the Highland Park Hotel.

**A NORTHWARD VIEW FROM THE BUNKER HILL MONUMENT.** The major land link connecting Chelsea and Charlestown appears in this additional panoramic view, *c.* 1874. Before 1803, when the bridge was built, a land trip from Chelsea to Boston required a circuitous route via Malden, Medford, Cambridge, and Roxbury via Boston Neck. Across the Mystic River and to the right of the bridge are located the brick row houses of Medford Street and the Chelsea waterfront. Today, the Maurice J. Tobin Memorial Bridge spans this river.

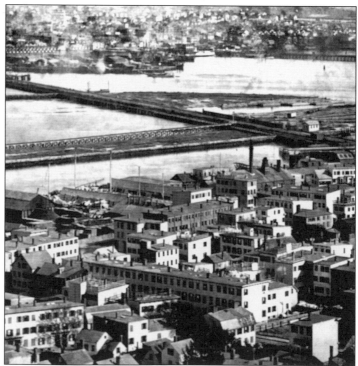

# Two

# PRE-FIRE VIEWS OF THE 20TH CENTURY

The beginning of Chelsea's 20th century coincided with the explosion in growth of picture postcards. The postcard was 100 years ago what e-mail is today—a fast, efficient means of communicating with relatives, friends, clients, and business associates. The medium also provided a way for people to show pride in their town. Everywhere in America, picture postcards were produced of churches, main streets, businesses, schools, events, and modes of transportation. Many businesses were formed in order to take advantage of this opportunity. Large companies, as well as amateurs, contributed to what is today referred to as the golden age of postcards. This boom lasted from the beginning of the 20th century through the end of World War I. Many postcard publishers produced Chelsea views; through such postcards, this chapter provides a glimpse of the city prior to the 1908 fire.

The least common and most unique views produced were photographic postcards. They were made in small quantities by photographers who were, for the most part, not identified on the card. Unfortunately, pre-fire Chelsea views of this type are scarce. The included street scenes date from c. 1905.

The Robbins Brothers Company of Boston and Germany published a small series of Chelsea postcards c. 1907, producing building views of excellent quality, color, and detail.

Approximately 30 other color postcards were printed; the only identifying feature is a "Printed in Germany" inscription on the back. The cards were issued with a three-digit series number on the front lower margin in red ink. Some of the views credited George F. Slade as photographer. Based on the actual examination of views, they were produced in greater numbers than the Robbins Brothers cards. Their print quality is excellent.

Photographer George F. Slade Jr. produced an unknown number of unique postcards c. 1906 at his studio, at 458 Broadway. The fine views of churches, schools, and main streets were issued in black-and-white. Slade later specialized in hand-colored photographs, producing White Mountain landscape views. In 1932, Slade's Art Shop operated at 396 Broadway. The family business lasted into the 1960s.

Collectively, the postcard production of these publishers and others has given us a detailed portrait of the city prior to 1908. Many of these cards are the only visual record available of what the city looked like almost a century ago.

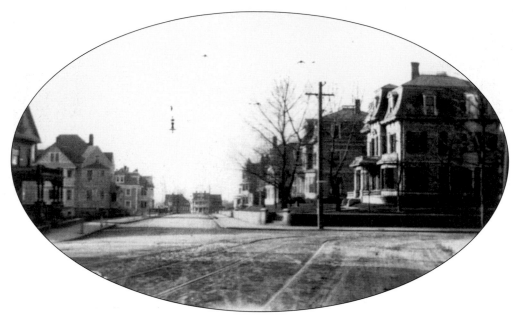

**COUNTY ROAD.** Taken from Washington Avenue looking west, just before the road turns right toward the Revere Beach Parkway, this early view dates from *c.* 1905. The mansion to the right was owned by Charles A. Campbell until *c.* 1900. Campbell was a prominent businessman in Chelsea whose interests in coal, lumber, and shipping date from the 1860s. This residential area was not touched by the disastrous fire that occurred three years later.

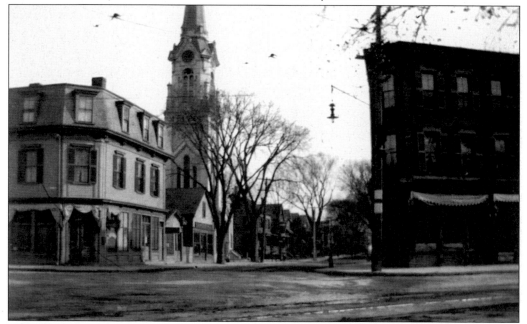

**CARY SQUARE.** This *c.* 1905 photograph view looks from Washington Avenue eastward down Cary Avenue. To the right, the road continues on to Broadway. On the left can be seen the Cary Avenue Methodist Church. The church building was later modified and the steeple removed. Today, it serves as Temple Emmanuel. In earlier times, the tidal wash from the Island End River (abutting the Naval Hospital grounds) came within a few feet of Cary Square.

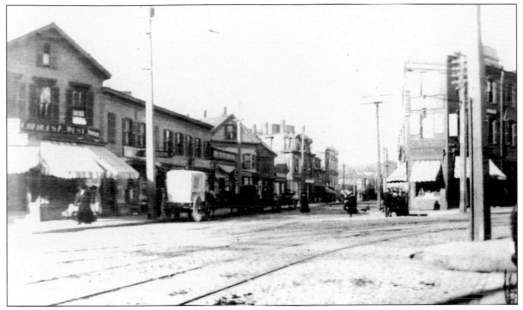

THE JUNCTION OF WASHINGTON AVENUE AND BROADWAY. Bellingham Square is seen here c. 1905. Every building in this view was destroyed by the 1908 fire, which leveled one-third of the city. The present city hall is located on the site of the building on the right. Broadway continues on to the right toward Mill Hill and Revere. Note the extent of the cobblestone-lined square in the view.

THE ODD FELLOWS BUILDING. The message from this postcard's sender states that the Odd Fellows building had recently been rebuilt. The post office was located on the first floor, and the Odd Fellows group occupied the upper levels. Taken in Chelsea Square, this c. 1906 view is historic; only one year before, this block was partially destroyed in the 1905 Academy of Music fire. Then, in 1908, both the Odd Fellows building and the post office were extensively damaged in the Chelsea conflagration.

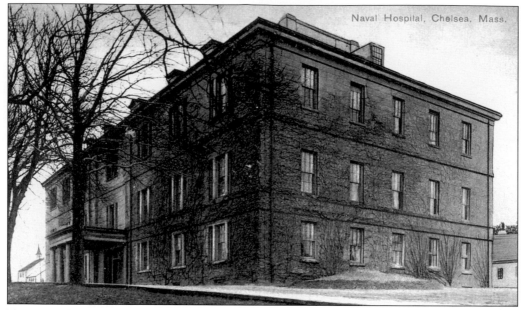

**THE NAVAL HOSPITAL.** This building, constructed in 1836 and expanded in 1865, was located on the southern slope of the Naval Hospital Hill, overlooking the Mystic River. Here, it appears to have a permanency to it, being constructed of Vermont granite; however, it served as the main naval facility on U.S. government grounds only until 1915, when a more modern building was opened on the hill's summit.

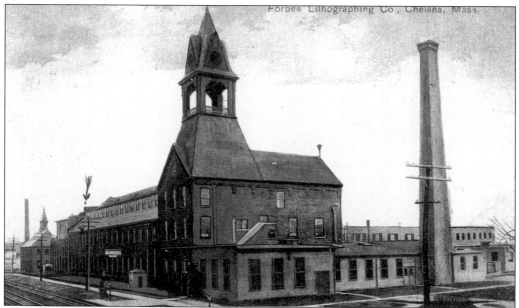

**THE FORBES LITHOGRAPHING COMPANY.** The bell and clock tower located at the southern end of the company's three-story complex are seen here *c.* 1907. The firm was started by William H. Forbes in 1862. By 1875, it had added locations in Boston and Roxbury. The company consolidated operations and moved to Chelsea in 1883. Forbes was primarily a manufacturer of high-quality lithographic can labels, cartons, and theatrical posters. The lithographic department was in business until 1968.

**FITZ PUBLIC LIBRARY.** This estate served as the city's library from 1885 to 1908. It was located at the junction of Broadway, Marlborough, and Matthews (now Library) Street, where the present library is today. Named after its benefactor, former mayor Eustace Fitz, the library was destroyed in the April 12, 1908, fire. One of the many tragedies that day was the destruction of historical records and artifacts of local history.

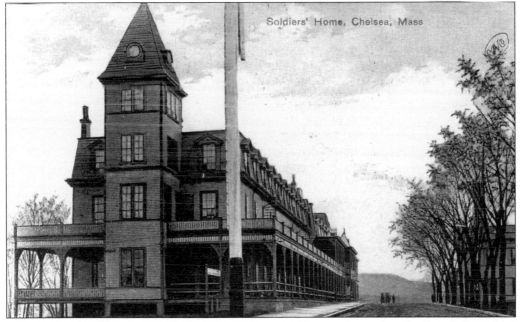

Soldiers' Home, Chelsea, Mass

**THE SOLDIERS' HOME.** This building, seen here *c.* 1907, was located at the Powderhorn Hill summit. In 1881, the Grand Army of the Republic (GAR) purchased the bankrupt Highland Hotel, its furnishings, and four acres of land for $20,000, or less than 20 percent of its original cost. The structure was remodeled into a Civil War veterans' hospital. Dedicated on June 8, 1881, the Soldiers' Home opened for admission on July 25, 1882.

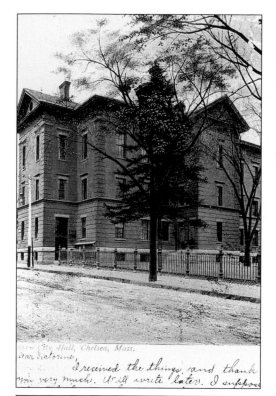

**THE OLD CITY HALL.** The original town hall, located on Central Avenue at the corner of Shurtleff, was constructed in 1853 at a cost of $3,325. The town offices initially shared space with a girls' grammar school. Chelsea's first mayor, Frank B. Fay, placed a new clock inside city hall when Chelsea became a city in 1857. It served the city for more than half a century until the building was destroyed in the 1908 fire.

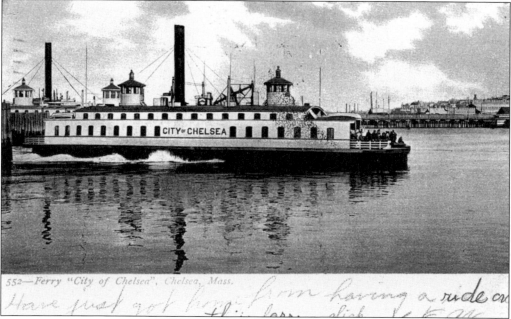

**THE FERRY *CITY OF CHELSEA*.** Ferry service was in continuous operation from 1631 to 1917. Plying between Chelsea and Boston's North End, it was the oldest ferry in the country. The *City of Chelsea* was one of two steam ferries built at Philadelphia in 1832. Here, the steamship departs the ferry slip at the foot of Winnisimmet Street. Behind and to the right are the Meridian Street Bridge and East Boston.

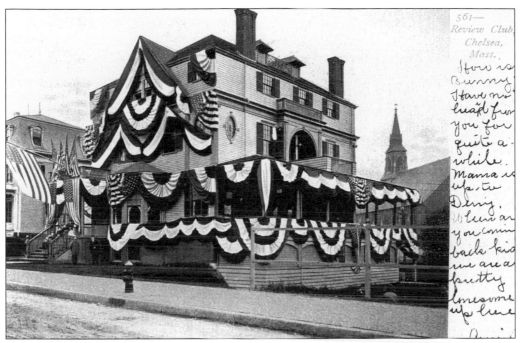

*How is
Bunny.
Have not
heard from
you for
quite a-
while.
Mama is
up to
Derry.
When are
you comin
back kid
we are a
pretty
lonesome
up here*

**THE REVIEW CLUB.** First formed in September 1869, the Review Club had occupied two other locations in the city center before moving to Crescent Avenue opposite the former Chelsea High School in 1889. This attractive home's cornerstone was laid on June 28, 1888. The social and literary club continued to be a cultural center for the well-to-do until it disbanded in 1918.

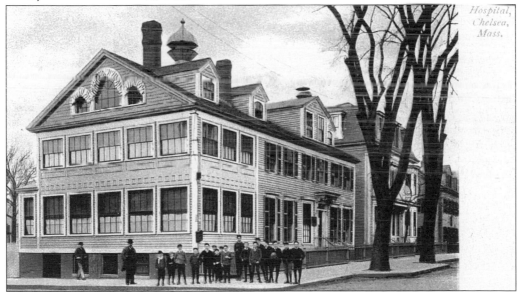

**FROST HOSPITAL.** This hospital was named for its main benefactor, Rufus S. Frost (1826–1894), a successful businessman and city mayor from 1867 to 1868. Dedicated on November 25, 1890, the building stood at Shawmut Street and Chester Avenue. In 1907, the Frost estate, on Bellingham Hill, was purchased for the purpose of building a hospital, to be named the Rufus S. Frost General Hospital. Unfortunately, the structure was destroyed in the 1908 fire, before its renovation was completed.

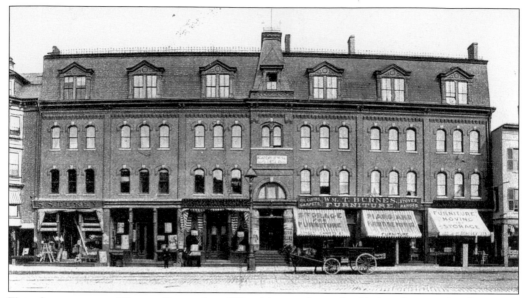

**THE ACADEMY OF MUSIC.** Located on Winnisimmet Street in Chelsea Square, this four-story brick building was founded by Isaac Stebbins in 1871. It housed a 1,350-seat theater and several local businesses. Many concerts were held here over the years. On January 12, 1905, a tragic fire destroyed the structure. It started shortly after the completion of a minstrel show performed by the local lodges of the Knights of Pythias.

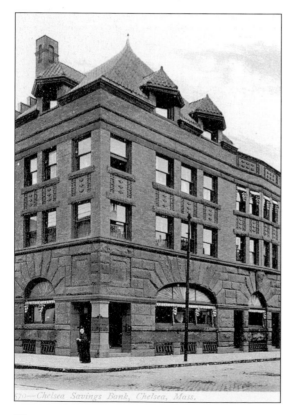

**THE CHELSEA SAVINGS BANK.** This bank was organized on May 11, 1854. Located at Broadway and Congress Avenue, the building was designed by S. Edwin Tobey. It first opened in October 1895. Previously, the bank had operated in the old city hall and at two other Broadway addresses. The brick building was a casualty of the great 1908 fire.

**THE WATER DEPARTMENT.** In 1898, when this photograph was taken, the city's water was supplied through the metropolitan system. This handsome structure, standing at Hawthorne and Park Streets, housed the pumping system. It was constructed in 1886–1887 through the efforts of the board of water commissioners, who included Isaac Stebbins, George E. Mitchell, and John H. Crandon. The building was destroyed in the 1908 conflagration.

**R. S. FROST NO. 3.** This charming firehouse, located on Shurtleff Street, was in existence from the late 1860s to 1908. It was one of two firehouses built as a result of the improved water service to the city in 1867, the other being Engine No. 2. Named for then mayor Rufus S. Frost, the building stood in the shadow of the old city hall (not shown). Unfortunately, both buildings were lost in the 1908 fire.

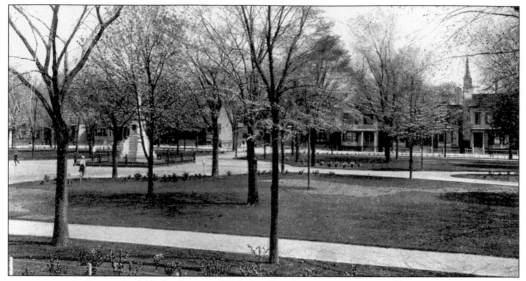

**UNION PARK.** Located at Fifth, Fourth, Walnut, and Cedar (now Arlington) Streets, Union Park and the Civil War Soldiers' Monument were dedicated on April 19, 1869. The park was where many people sought refuge from the burning flames and smoke of the great 1908 fire. The monument was relocated in 1911 to Bassett Square, across from the present city hall on Broadway, where it currently stands.

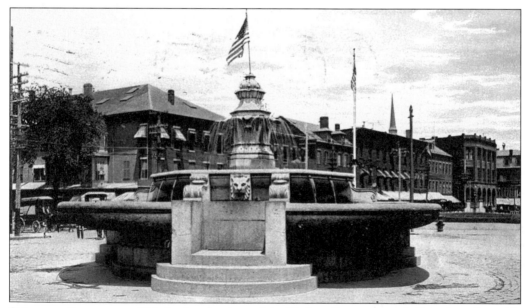

**STEBBINS FOUNTAIN.** This landmark, situated in Chelsea Square, was dedicated on June 30, 1897. It was named for Isaac Stebbins (1817–1888), a successful banker and founder of the First National Bank (formerly the Tradesman Bank) of Chelsea, a businessman, and a mayor of the city, who bequeathed $6,500 to have the fountain built. The fountain replaced an earlier one located where Columbus Park is today. After 107 years, Stebbins Fountain still graces Chelsea Square.

**THE YMCA BUILDING.** A lot on Hawthorne Street, near Bellingham, was purchased from George H. Buck in 1897 with the goal of establishing a permanent home for the Young Men's Christian Association. After many years of temporary residences, the organization was able to secure funds for the construction of the building in 1904. After only several years in existence, the six-story structure became a casualty of the 1908 fire.

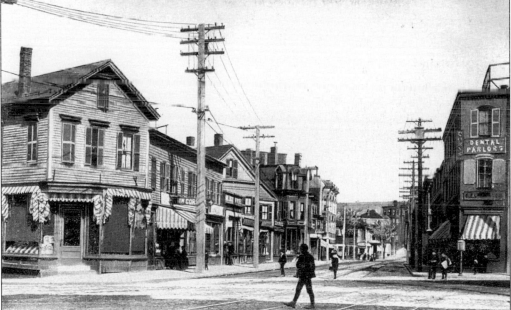

**WASHINGTON AVENUE.** This pre-fire view shows one of Chelsea's busy business districts. The building displaying the "Dental Parlor" sign was located on the site of the present city hall. Just to the right and out of view stood Chemical No. 1, Ladder No. 1 (opposite the present city hall on Broadway). It was a common sight to see firefighter Allie Francis lead the station's fire horses on their daily walk around Bellingham Square.

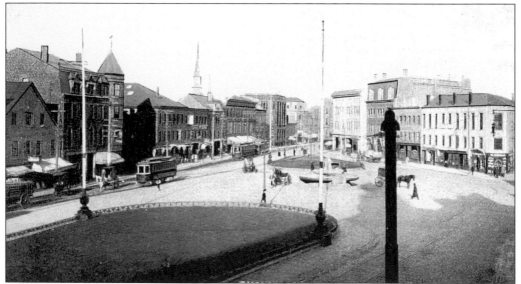

**THE WINNISIMMET PARKWAY.** This bird's-eye view of Chelsea Square dates from the 1890s, prior to the building of the courthouse. Stebbins Fountain is located in the left center, between the two semi-triangular green spaces. The 1874 mansard-roofed Wheeler Building, located at Broadway and Second, is on the right. It was named for Dr. William G. Wheeler and was later remodeled, with a turret, by his son in 1898.

**CHELSEA SQUARE.** This view was taken looking in the opposite direction from the previous one. The turreted Wheeler Building, which still stands today, is on the left. Farther up Broadway is the Chelsea Trust Company, later destroyed in the 1908 fire. On the right are the off-white Odd Fellows building, the W. T. Burnes Furniture Company (with a slate mansard roof), the Park Hotel (where the 1908 fire was stopped), and Gerrish Hall (where Abraham Lincoln spoke in 1848).

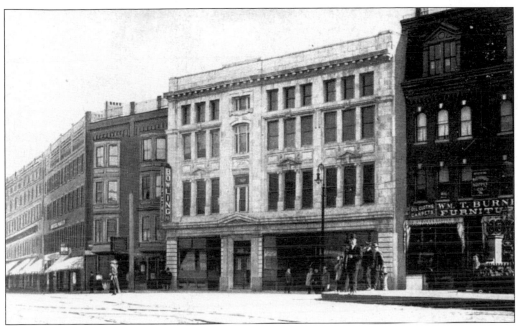

**THE POST OFFICE.** The Odd Fellows building was built following the 1905 Academy of Music fire. The post office, on the lower floor, had only been in business at this location for a short time when the building was destroyed in the 1908 fire.

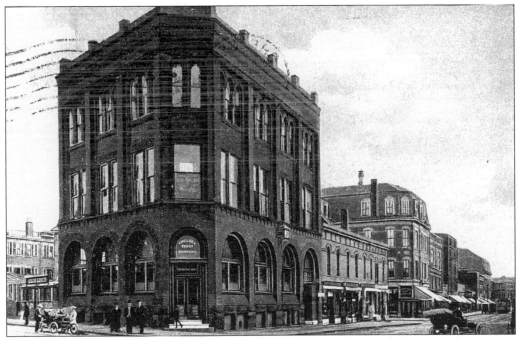

**THE CHELSEA TRUST COMPANY AND BROADWAY.** The bank building was located on Broadway at Everett Avenue. For a time, the structure housed the First National Bank. It was one of three banks lost in the 1908 fire.

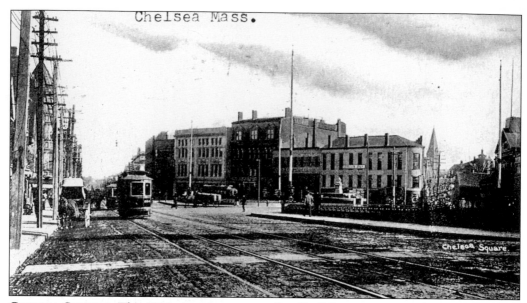

**CHELSEA SQUARE.** This 1906 view shows a couple of buildings not seen in the square view on page 32. On the right are the steeple of the First Baptist Church and the Grand Army Hall (behind the right flagpole). Originally the Park Street Methodist Church, the hall was subsequently sold to Grand Army Post 35. The group then remodeled it, including removing the steeple and front columns. The Grand Army Hall was dedicated in 1884.

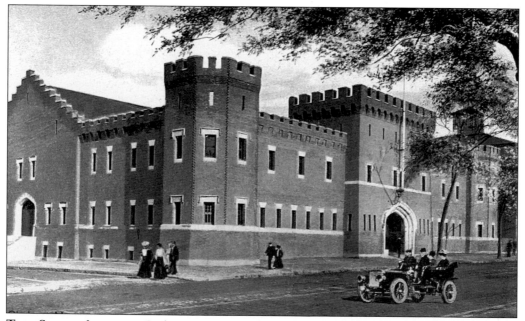

**THE STATE ARMORY.** Built in 1907, this fortresslike structure was located on Broadway opposite Matthews (now Library) Street. The steeple of the old Saint Rose School is visible through the tree branches on the right. The building, heavily damaged in the 1908 fire, was rebuilt on the same site.

34

**THE WILLIAMS SCHOOL.** The original Williams School building, constructed in 1860, stood on Walnut Street near Fourth. It was initially called the Walnut Street School while serving as a grammar school for boys. A 500-seat hall was located on the top floor. The structure did not survive the 1908 fire.

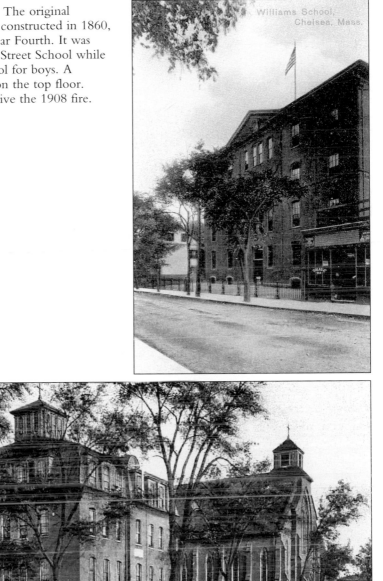

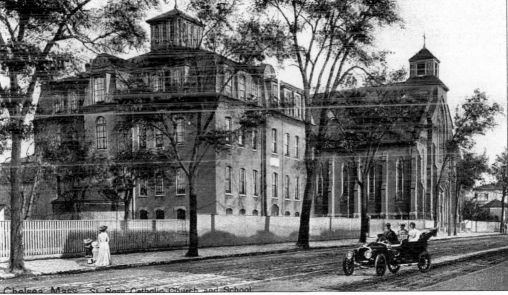

**ST. ROSE CATHOLIC CHURCH AND SCHOOL.** This *c.* 1906 view shows the second-generation church building and school, located on Broadway near the railroad tracks. The church was dedicated on August 30, 1866, to accommodate a growing Irish Catholic population. In 1871, a girls' grammar and high school was constructed next-door. The church and school served the community for many years. Following the destruction of both buildings in the 1908 fire, the school and church were rebuilt on the same site.

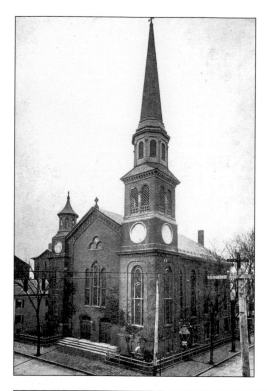

**THE UNIVERSALIST CHURCH.** Built in 1850 and enlarged in 1862, the church was located at the corner of Fourth Street and Chestnut, its most distinguishing features the beautiful steeple and graceful lines. Rev. R. Perry Bush was the most renowned of the church's pastors, serving from 1892 to 1922. He not only witnessed the destruction of the church in the 1908 fire but also oversaw the effort to fund and rebuild its replacement.

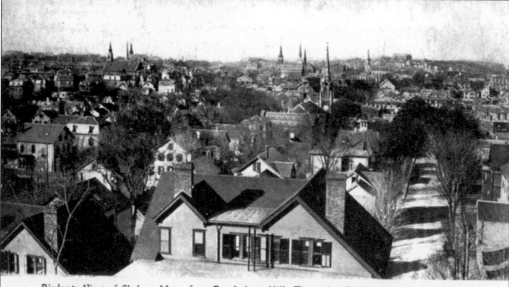

Birdseye View of Chelsea, Mass. from Powderhorn Hill. The entire district shown in this view with the exception of the houses in the immediate foreground was entirely destroyed in the Big Fire, Apr. 12, 1908.

**A BIRD'S-EYE VIEW OF CHELSEA FROM POWDERHORN HILL.** This view looks southward toward the U.S. hospital grounds and beyond. Most of the buildings pictured were destroyed in the great 1908 fire, with the exception of the ones in the immediate foreground. The Marine Hospital building can be seen on the right. Reminiscent of an old European city, church steeples grace the horizon.

# Three
# THE GREAT CHELSEA
# FIRE OF 1908

This tragic event, also known as the Chelsea conflagration, occurred on Palm Sunday, April 12, 1908. Nothing like this had ever before been witnessed by the people of the city. When it was over, almost 500 acres had been burned, destroying more than 2,800 buildings, 13 churches (including all 3 synagogues), 8 schools, 3 banks, 4 newspaper plants, and 2 fire stations. The fire also claimed city hall, the library, the Armory, the Masonic Temple, the YMCA, the board of health building, Frost Hospital, the post office, and more than 700 businesses. A total of 18 people were killed, and about the same number were declared missing. More than 17,000 people became homeless as a result of the fire.

Postcards of the fire disaster can be grouped into two categories: photographic and printed black-and-white. In addition, lithographic cards were produced in color; however, only a few titles were made. None are included in this volume.

The most unusual postcards produced were photographic views. The author has found very few duplicates, suggesting they were produced in small quantities. The print quality of the cards examined is excellent. Scenes of the fire in progress are rare, because the fire moved so quickly that few people had time to take photographs. Included are dramatic, general views of ruined churches and banks, and a destroyed fire engine. The most comprehensive series produced was a set of 11 unique photographic images taken of the ruins on April 20 and 21. The photographer documented and initialed the back of all the postcards with the initials H. C. A. To date, the identity of the photographer has not been determined. The images are of high quality and show some unique scenes, including a house that survived the fire, as well as Bellingham Hill and some rarely seen East Boston locations.

Several other postcard series of the fire were produced in high quantity. They include Reichner Brothers, 564 Washington Street, Boston, Munich, Leipzig; the Metropolitan News Company, Boston; and the New England Paper and Stationery Company, Ayer. The views are comprehensive and show buildings, streets, people, and before-and-after scenes.

A great variety of postcards was produced of the 1908 Chelsea fire. Further discovery of new views will enhance our understanding of that fateful day and the disaster that catapulted Chelsea into a reconstruction period, transforming the city permanently.

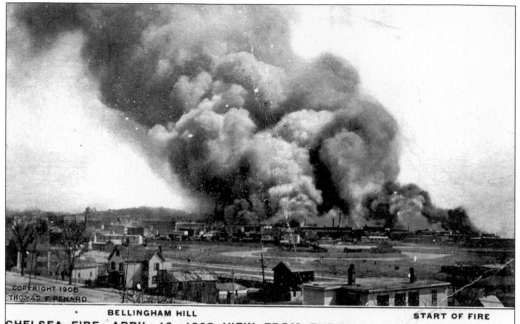

BELLINGHAM HILL
START OF FIRE
CHELSEA FIRE, APRIL 12, 1908--VIEW FROM EVERETT

**THE CHELSEA FIRE, A VIEW FROM EVERETT.** This printed postcard, photographed by Thomas F. Penard, is one of the few taken of the fire as it raged. Bellingham Hill appears in the left center. The scene was taken from the top of a multi-deck house or building in Everett. The Revere Beach Parkway can be seen in the immediate left foreground.

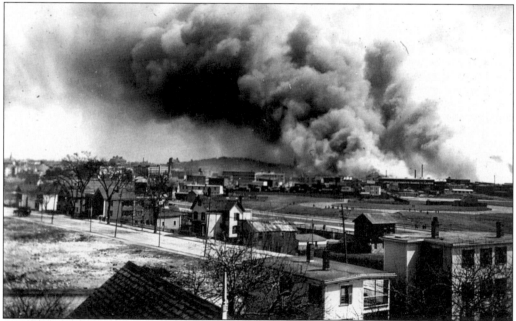

**THE CHELSEA FIRE, A VIEW FROM EVERETT.** According to the police records, the fire started in some rags in a Summer Street dump and quickly spread to the Boston Blacking Company, near the Everett line. The first fire alarm was struck at 10:44 a.m. from Box 24. A total of 24 alarms sounded that day, not including ones from neighboring cities.

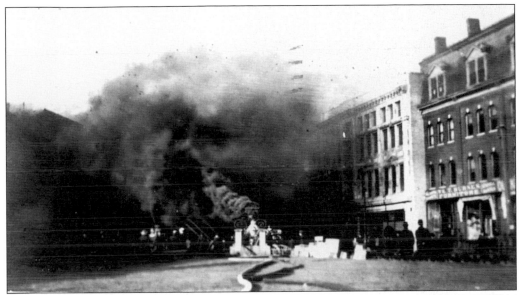

**CHELSEA SQUARE.** One of a unique set of three photographs, this card is postmarked two days after the fire. The view shows the southern limit of the fire in Chelsea Square. The heavy smoke, coupled with strong winds, created difficult conditions for fighting the fire. The Odd Fellows building appears on the right. Although this block was destroyed, the fire stopped before reaching the Park Hotel, just out of view to the right.

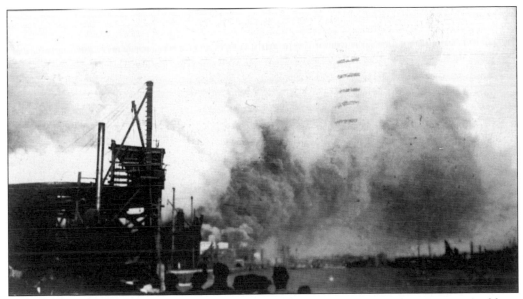

**ALONG THE WATERFRONT.** The southeastern section of the city, near East Boston, is ablaze. Likely taken from Marginal Street, this photograph shows people helplessly watching as the fire races unimpeded down Bellingham Hill toward the oil tanks along the Chelsea–East Boston line.

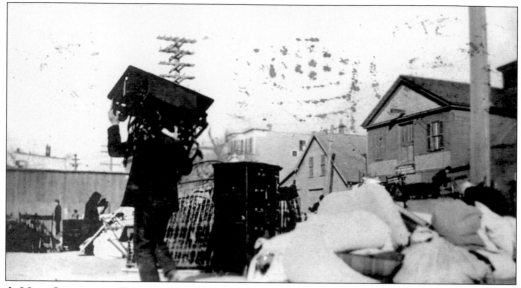

**A MAN SALVAGING FURNITURE.** This dramatic image depicts what people were doing all over the city: trying to salvage any belongings that they could from their homes. This man carries a sewing table or desk on his back. The postcard sender's message states that people moved their things to the streets and fields, only to have them burn there.

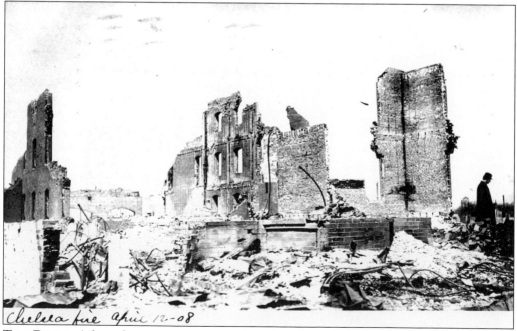

Chelsea fire april 12-08

**THE RUINS.** A lone figure appears among the ruins of a large building. The exact location is unknown. Note the thoroughness of the destruction. Not only were the conditions extremely dry when the fire began, but also the wind was blowing in excess of gale-force strength. As a result, very few structures in the path of the flames escaped unscathed.

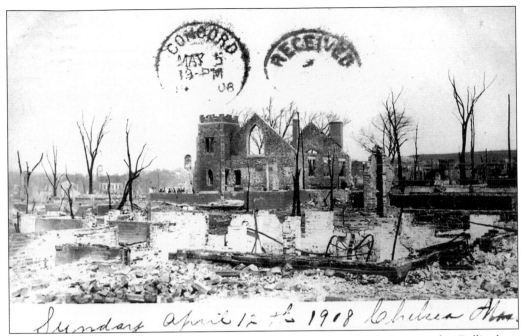

*Sunday April 12th 1908 Chelsea Mass.*

**THE BELLINGHAM METHODIST CHURCH AND VICINITY.** Also known as the Bellingham Church, the building was located on Bellingham Street near Shurtleff. Dedicated on Easter Sunday 1907, the church was burned in the conflagration almost a year later. Many different views of the church ruins were produced. One postcard message from the sender asks the addressee if the image reminds her of an English abbey.

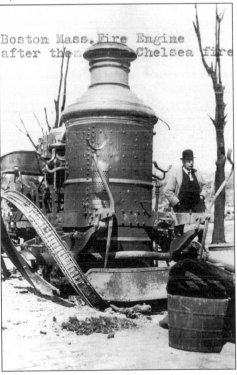

**A BOSTON FIRE ENGINE.** Of the 39 fire engines fighting the flames that day, 3 were destroyed. Of those three, 2 were from Boston, and 1 was from Lynn. According to Walter Pratt in *The Burning of Chelsea*, a Boston engine was lost near the burned East Boston and Boston & Albany Railroad Bridges. This may be the view of that engine.

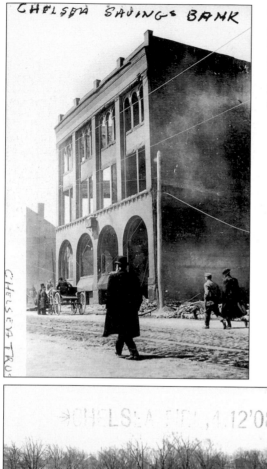

**THE CHELSEA TRUST COMPANY.** This undated photo postcard is incorrectly labeled Chelsea Savings Bank. Here, several men walk south on Broadway toward Chelsea Square. The bank building, located on Broadway at Everett Avenue, was destroyed by flames that swept up Everett Avenue from the fire origin.

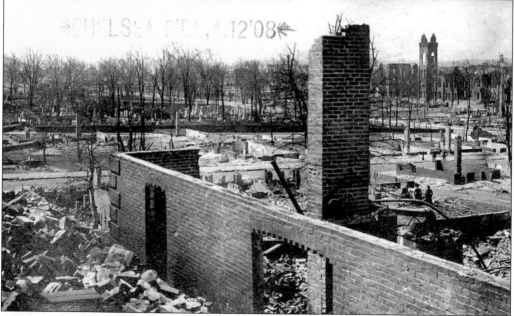

**A PANORAMA OF RUINS.** Looking toward the First Baptist Church and city hall next door, this view was taken from Bellingham Hill. The Garden Cemetery is clearly visible in the left center. Bordered by Central Avenue, Shawmut Street, Chester Avenue, and Lynn Street, the cemetery is where many people sought refuge during the fire, only to be driven out by the smoke and flames. Note the solid brick foundation in the foreground, undamaged by fire.

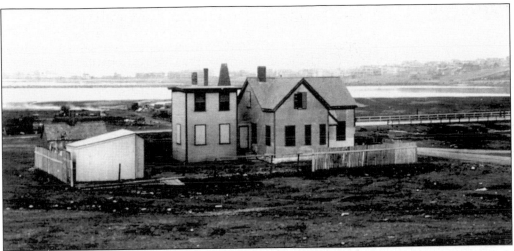

**A LITTLE HOUSE.** This dramatic image, taken eight days after the fire, on April 20, 1908, reveals one of the houses in the burned district untouched by fire. How the building survived is a miracle. The exact location is not known.

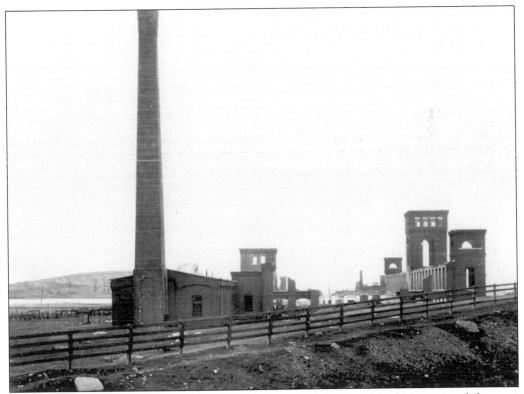

**THE BOX FACTORY.** Taken on the railroad lot near East Boston, this photo postcard does not identify the company shown. It could be Parsons Manufacturing, maker of wooden boxes and kindling wood, located at 157 Marginal Street.

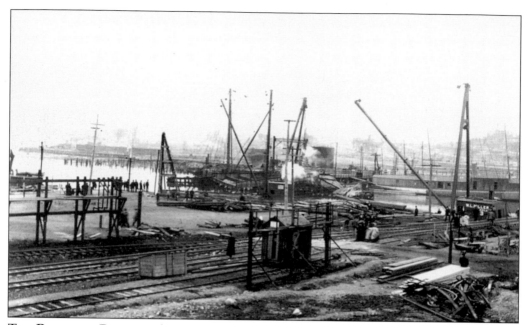

**THE RAILROAD BRIDGE.** This view of Chelsea was taken on April 20, 1908, from East Boston. Two bridges were destroyed the day of the fire: the Boston & Albany Railroad Bridge and the East Boston Bridge, connecting Eastern Avenue in Chelsea and Chelsea Street in East Boston. In this scene, the latter bridge is out of commission. On the right, visible through the haze, are Bellingham Hill and the ruins of the Highland School, on Cottage and Highland Streets.

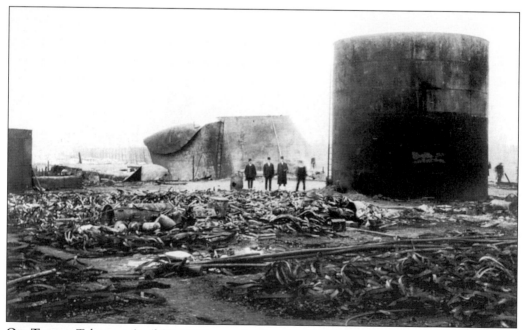

**OIL TANKS.** Taken on April 20, 1908, near the East Boston Bridge, this image shows a destroyed tank and at least one that has survived. The oil tank fires sent flames several hundred feet into the air. The resulting glare would account for the reports of the fire being seen at night from as far away as Portland, Maine.

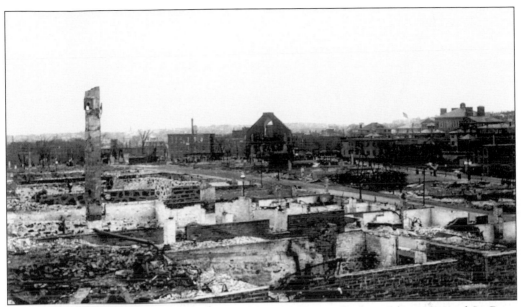

**A PANORAMA FROM BELLINGHAM HILL.** This April 20 view looks northwest toward St. Rose Church and the carbarns of the Boston Elevated Railway. The ruins of the church are seen in the center. The new Chelsea High School, built on Crescent Avenue *c.* 1904, is visible on the right. Untouched by fire, the three-story brick school served as headquarters of the Chelsea Relief Committee following the disaster.

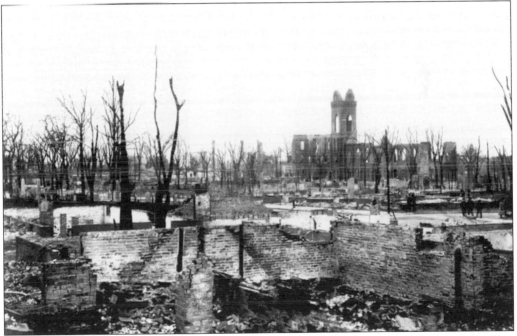

**A PANORAMA FROM BELLINGHAM HILL.** Looking southwest toward city hall and the First Baptist Church, this view was taken on April 20, 1908. Barely visible on the left is city hall. In the left center are some monuments from the Garden Cemetery, at Chester Avenue and Shawmut Street. In the right center are the ruins of the church.

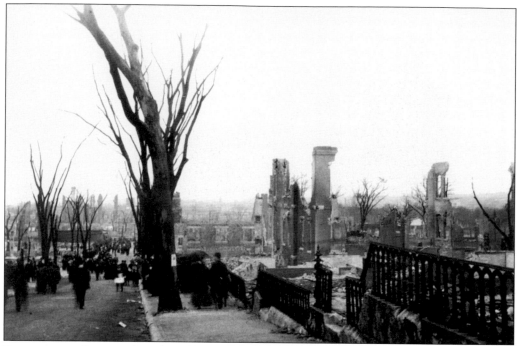

**BELLINGHAM STREET.** People walk toward Bellingham Square on April 20, 1908. The once-beautiful residential street lies completely in ruins. To the left of center is the Bellingham Methodist Church (the visible sidewall with the three windows). In the right center are the walls of the old Chelsea High School, built *c.* 1873. Note the fancy iron railings undamaged by the fire.

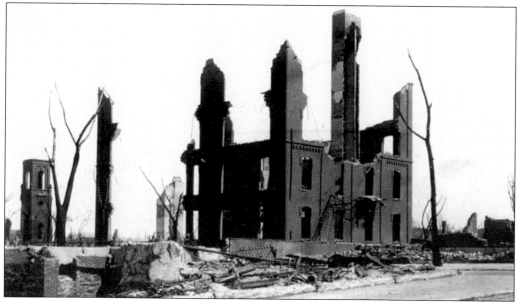

**THE WILLIAMS SCHOOL.** The school served the city for almost 50 years until destroyed in the great conflagration. This well-composed image of the ruins was taken from the intersection of Fourth and Walnut Streets on April 21, 1908. The ruins of the Central Congregational Church are visible on the left.

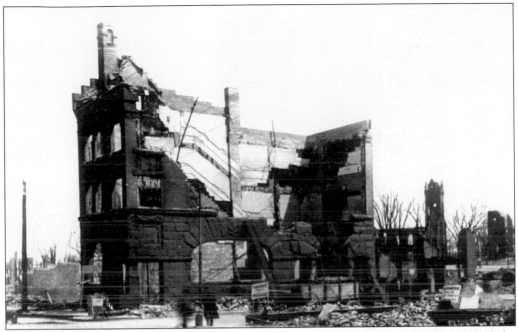

THE CHELSEA SAVINGS BANK, BROADWAY. Photographer H. C. A. describes in detail the event that day: "Not more than ten seconds after this view was taken, the further side wall fell out. I suppose that this is the last view ever taken of this building as you see it." This image was taken on April 21, 1908.

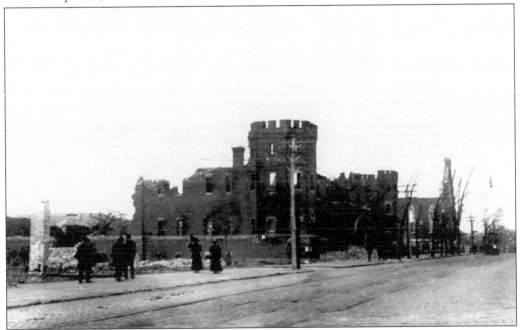

THE ARMORY ON BROADWAY. This view looks up Broadway toward the ruins of St. Rose Church and beyond on April 21, 1908. The Armory was rebuilt after the conflagration only to be destroyed in a 1952 fire. Workers who later razed the remains of the brick structure in 1957 stated that, despite two fires, the 24-inch-thick walls were still in good condition.

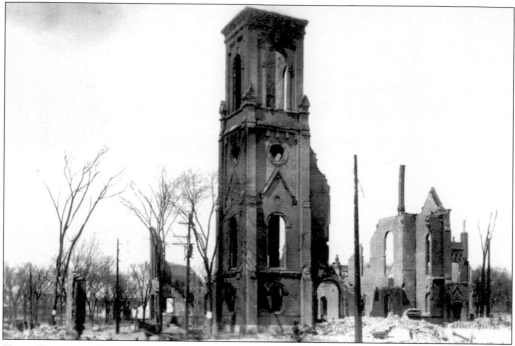

**THE CENTRAL CONGREGATIONAL CHURCH.** The building was one of the largest church structures in the city. The fire of 1908 took only minutes to race through the edifice, from the basement to the steeple. This image shows the remaining ruins nine days after the start of the fire.

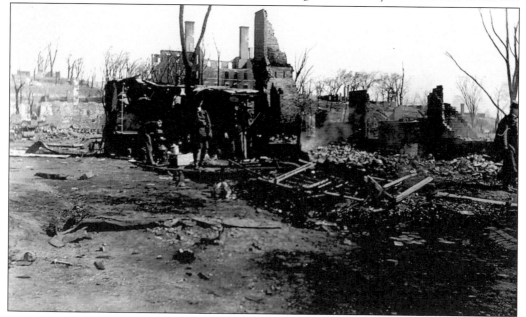

**SOLDIERS ON DUTY.** Some 1,200 troops were sent into the city to prevent looting and maintain order once the fire was brought under control. Several military units participated, including the Coast Artillery, the 5th Infantry, the 8th Infantry, and the 1st Corps of Cadets. Martial law was declared at 10:30 that night. In this image, troops cook their dinner amongst the ruins. The location is not known, although the hilly terrain likely indicates Bellingham Hill.

**THE FIRST BAPTIST CHURCH (BEFORE AND AFTER).** Located on Central Avenue at Shurtleff, the church stood across the street from the old city hall. The imposing structure, with its distinctive steeple, was built in the 1870s. It stood for more than 30 years before being destroyed in the great Chelsea fire of 1908.

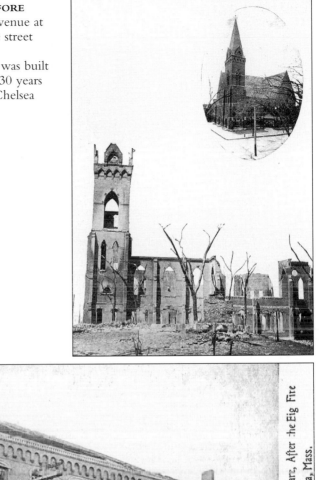

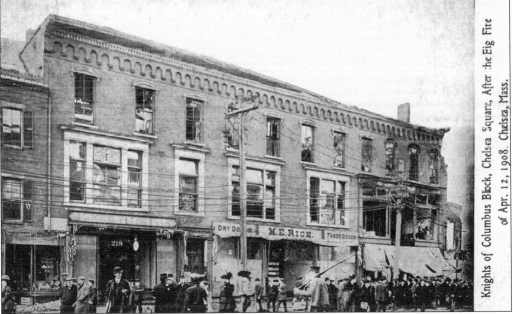

Knights of Columbus Block, Chelsea Square, After the Big Fire of Apr. 12, 1908. Chelsea, Mass.

**THE KNIGHTS OF COLUMBUS BLOCK.** This building, on Broadway in Chelsea Square, at the time housed M. E. Rice's Store, one of the largest dry goods dealers in the city. M. E. Rice opened his first shop in Chelsea in 1880 under the name Rice and Miller. Two years later, he bought out his partner. In 1897, Rice bought the adjoining store at 224 Broadway for more space. The store sold men's furnishings, linens and domestics, gloves and hosiery, and handkerchiefs and laces.

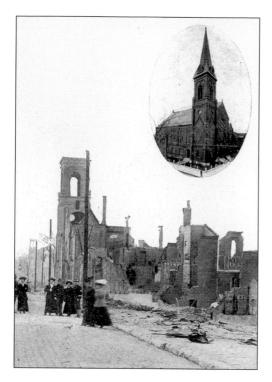

**THE CENTRAL CONGREGATIONAL CHURCH (BEFORE AND AFTER).** The cornerstone for the third church formed by the Winnisimmet Congregational Society in the city was laid in 1870 at the corner of Chestnut and Fifth Streets. The church occupied the site for more than 35 years before being destroyed in the 1908 fire. In the after view, part of the Universalist church can be seen to the left of the Central Congregational Church tower.

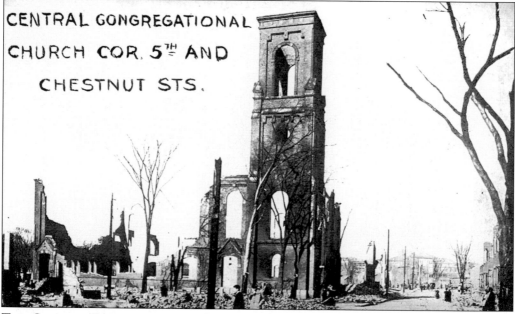

CENTRAL CONGREGATIONAL CHURCH COR. 5ᵀᴴ AND CHESTNUT STS.

**THE CENTRAL CONGREGATIONAL CHURCH.** This view of the ruins shows a close-up of the bell tower. The Congregationalists first met in Slade's Hall in 1840. There, plans were drawn up for building a church. In 1842, a church was constructed on the site of today's St. Stanislaus. It was named the Winnisimmet Congregational Church. Because of significant growth, the Congregationalists built another church in Chelsea Square before a group spun off and erected this one at Fifth and Chestnut Streets.

**THE UNIVERSALIST CHURCH (BEFORE AND AFTER).** As pastor of the church, Rev. R. Perry Bush was deeply attached to the parish he helped nurture. An 1879 graduate of Tufts University, earning a doctor of divinity degree, he was ordained in the church on July 30, 1879. Bush became pastor of the Universalist church in 1892, after spending 13 years in an Everett parish. On the day of the fire, he stood on the church steps with parishioners until they were forced to flee to safety.

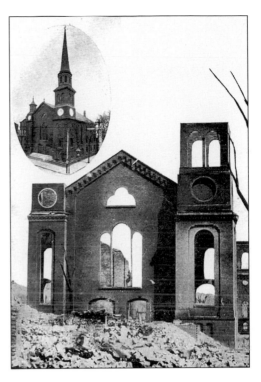

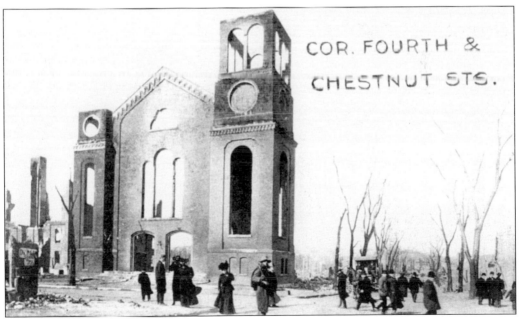

**THE UNIVERSALIST CHURCH.** The church was one of 13 that burned on April 12, 1908. The roots of the First Universalist Church go back to 1842, when congregants met in the loft of a sawmill on Fifth Street near Broadway. It was another eight years after the fire before the Chestnut and Fourth Street building was dedicated.

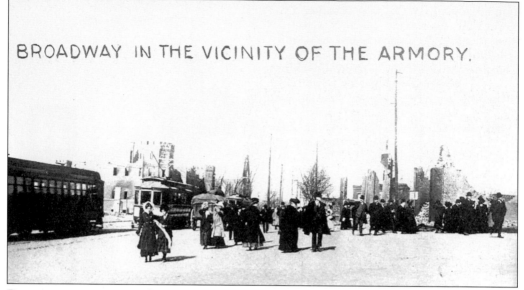

BROADWAY IN THE VICINITY OF THE ARMORY.

**BROADWAY, NEAR THE ARMORY.** Broadway was one of the main trolley arteries in the city. After the carbarns of the Boston Elevated Railway were destroyed in the fire, the most efficient means of travel around the city was by foot. However, within a few days, a temporary office was set up to coordinate the system, and the trolleys were running again. This postcard shows, from left to right, the ruins of the Armory, St. Rose Church, Fitz Public Library, and several unidentified buildings.

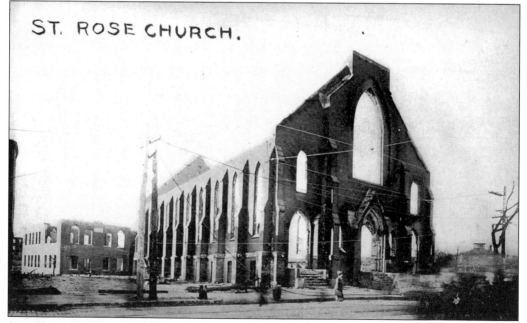

ST. ROSE CHURCH.

**ST. ROSE CHURCH.** Melrose firefighters used the railroad tracks next to the church as a firebreak, to prevent the flames from crossing the railroad bridge and continuing up Broadway. A contingent of men crossed the railroad tracks and ran fire hose up the steep bank behind the church, where they heroically fought the church fire. Their effort ultimately succeeded in stopping the fire in this sector, but not before St. Rose Church was reduced to ruins.

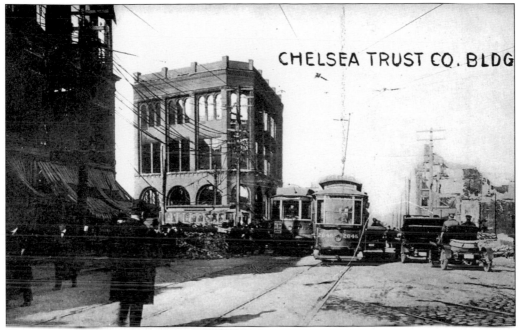

**THE CHELSEA TRUST COMPANY.** In this view, taken in Chelsea Square looking up Broadway, the Chelsea Trust Company is the large, ruined building in the left center, at the corner of Everett Avenue. Farther up Broadway, on the right, is the damaged wall of the Chelsea Savings Bank, at the corner of Congress Avenue. Note the traffic jam on Broadway. According to Walter Pratt's account of the fire, the militia was quartered in stalled trolley cars in the square.

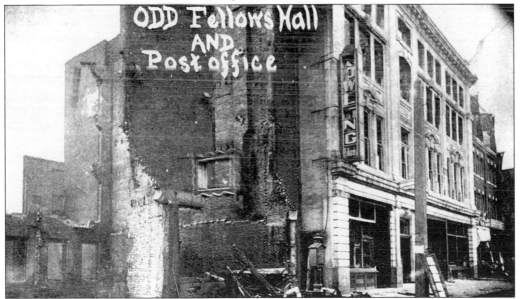

**THE ODD FELLOWS HALL AND POST OFFICE.** The three-story white granite building received extensive damage in the fire. Within a short time, a permit was granted to rebuild on the site. Unfortunately, a side wall left standing during the demolition was weakened by the removal of adjacent walls. Coupled with the weakening of supports during reconstruction, this resulted in the wall's collapse on August 25, 1908. The tragedy killed 8 people and seriously injured 13.

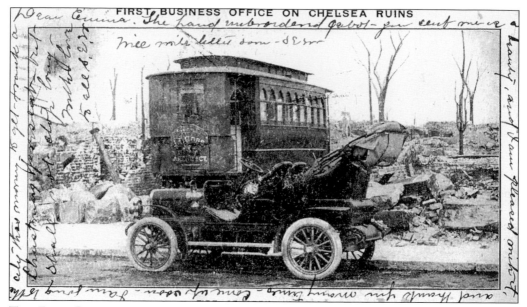

THE FIRST BUSINESS OFFICE ON CHELSEA RUINS. Several post-fire accounts tell of businesses that set up temporary offices around the city to get banks, transportation, and other services running again. This view shows the first business to open after the fire. The sign on the front of the trolley advertises J. Cobb, Architect. Other businesses followed suit. Temporary accommodations were secured at 27 Park Street for the three banks destroyed in the fire.

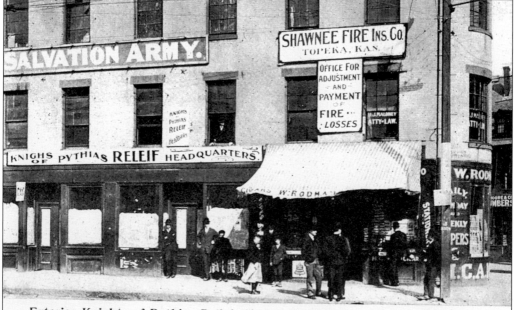

THE KNIGHTS OF PYTHIAS RELIEF. This view of Chelsea Square's Gerrish Hall shows the Salvation Army barracks and the Knights of Pythias headquarters, two of the many places of refuge for fire victims. Among the locations serving in this capacity were the Soldiers' Home, the Cary Avenue Methodist Church, and the First Congregational Church.

# Four

# RECONSTRUCTION

# AND AFTER

The period of reconstruction officially lasted from 1908 to 1912. The task of rebuilding the burnt district was a major effort requiring extraordinary measures. Therefore, a board of control was formed to run the city during the rebuilding phase, replacing the board of aldermen, the mayor, and the school committee. The board of control consisted of five professionals appointed by Gov. Eben S. Draper: William E. McClintock, Alton Briggs, George H. Dunham, A. C. Ratshesky, and Mark Wilmarth.

On June 4, 1908, the board of control took over the running of the city. Its first task was to float a bond issue of $1 million. Once the money had become available, several major building projects were funded: the Williams and Shurtleff Schools, city hall, the city stables, the Central Fire and Engine No. 5 stations, and the public library. Philanthropist Andrew Carnegie also provided money for the new library, giving $20,000 for the purchase of books.

In 1912, the city voted to abolish the commission and return to the board of aldermen and mayor.

Many different publishers issued postcards between 1908 and 1930. A small number of photographic postcards from the period of 1910 to 1918 depict the public library, city hall, Broadway, and Washington Avenue. None identifies the photographer. J. V. Hartman issued a fine series c. 1910 of post-fire Chelsea, showing views of Chelsea Square and the new firehouses. The Forbes Lithograph Manufacturing Company issued a beautifully colored postcard of its complex in 1908.

Another high-quality series was published by druggist C. W. Freeman and Thomson & Thomson. Both postcard types were characterized by a light gray-and-white border around a black-and-white image. The included views show newly built churches and schools and Broadway. The print quality is excellent. A small percentage of cards were hand colored.

A number of postcards were produced by an unknown maker with printed red titles. Colorful views of the Chelsea Ferry, Chelsea Square, and the courthouse were issued between 1910 and 1912. A slightly later series from the early 1920s showcased the new Armory, Frost Hospital, the YMCA, and some residential streets. The postcard had printed black titles on the front and green printing in the message area on the back.

The post-fire period was decently covered in postcard images. Undoubtedly, there was great pride in the rebuilding of the city, as reflected in the diversity of views.

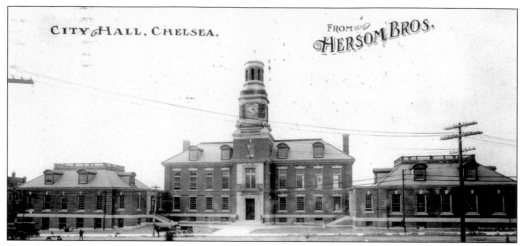

**THE NEW CITY HALL.** Located on land bounded by Broadway, City Hall Avenue (formerly Library Street), and Washington Avenue, this building replaced the original structure destroyed in the Chelsea fire. Modeled after Independence Hall in Philadelphia, the new city hall was dedicated on October 22, 1908. Among the famous people in attendance that day were Henry Cabot Lodge and John F. "Honey Fitz" Fitzgerald. This early view dates from *c.* 1909.

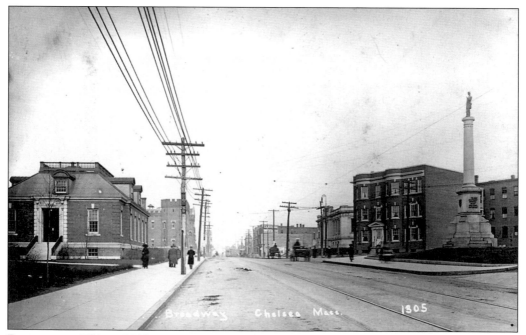

**BROADWAY.** This *c.* 1913 street scene was taken outside the city hall entrance. A wing of the building is seen in the left foreground. Up Broadway, on the left side, is the new Armory, located on the site of its predecessor. Across the street is the front façade of the new library. In the right foreground are Basset Square and the Soldiers' Monument (previously located in Union Park).

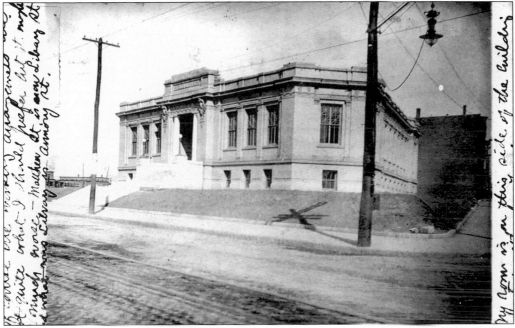

**THE NEW PUBLIC LIBRARY.** The newly built library was opened for circulation on October 1, 1910, according to Medora J. Simpson, the sender of this postcard. Simpson was the first librarian of the building, still situated on Broadway and bordered by Library (formerly Matthews) and Marlborough Streets. The November 14, 1910, postmark indicates the photograph was likely taken when the building first opened. A skylight in the rotunda is named in Simpson's honor.

**WASHINGTON AVENUE.** Starting at Bellingham Square and ending in Woodlawn, Washington Avenue is one of the longest streets in Chelsea. Named after the nation's first president, it commemorates his visit to the city in 1776. This *c.* 1910 view, taken near Crescent Avenue, looks toward Cary Square. The silhouette of the Cary Avenue Methodist Church is visible on the horizon. This section of the city was untouched by fire, and consequently, many of the houses still stand.

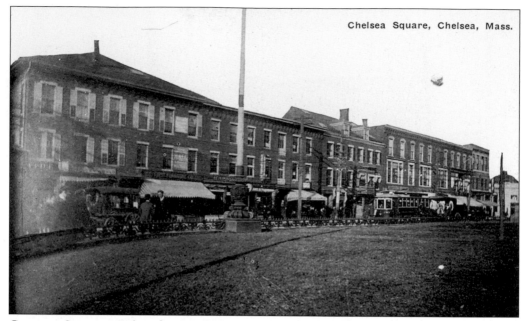

**CHELSEA SQUARE.** Taken from North (now Columbus) Park, this *c.* 1910 view looks toward the block of buildings on Broadway. Prior to the opening of the 1898 courthouse, Chelsea District Court was located in the building behind the trolley. On the far right is the Chelsea Trust Company.

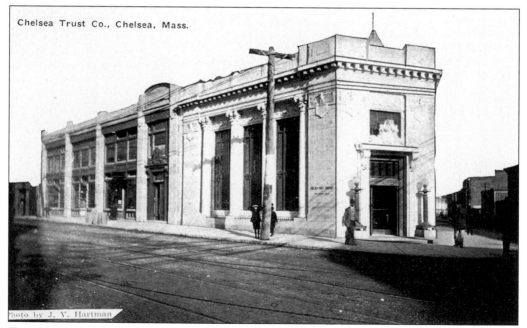

**THE NEW CHELSEA TRUST COMPANY.** The new bank building, seen here *c.* 1910, was constructed on the same site as its predecessor, at Everett Avenue and Broadway. At the time the image was taken, the bank boasted capital of $250,000. It offered safe-deposit boxes to rent for $5 to $25 per year (a lot of money in those days). George W. Moses served as president.

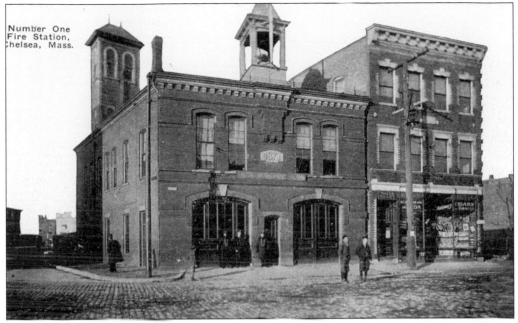

**THE ENGINE ONE FIREHOUSE.** The 1871 Park Street firehouse is pictured here in a Hartman photograph taken *c.* 1910. When first built, the building housed two steamer pumps (steamers No. 1 and 2). The old police lockup was located directly behind the firehouse on Division Street. Today, a dry cleaning business occupies the structure.

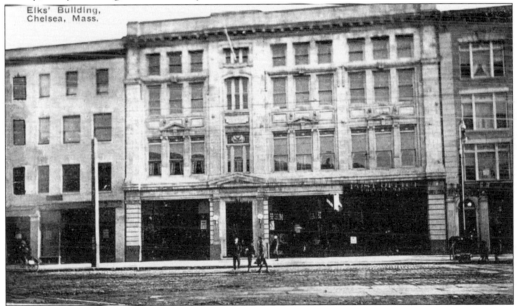

**THE ELKS BUILDING.** This *c.* 1910 view shows the Elks building, which was located near North (now Columbus) Park in Chelsea Square. The address is historic. In 1851, the Broadway Congregational Church, an early city landmark, was built on the site. The Odd Fellows building was constructed on the same location *c.* 1906. In 1908, the Odd Fellows building was heavily damaged in the Chelsea fire. The remaining structure was subsequently refurbished, using the original façade (pictured here).

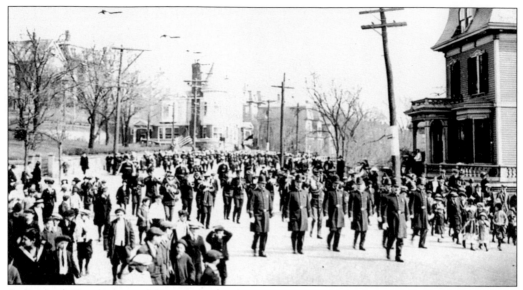

**A Police Department Parade.** In this *c.* 1918 photograph taken from County Road, Chelsea policemen march up Washington Avenue. The specific event is unknown. As the view indicates, Washington Avenue was lined with many fine Victorian homes. Of special note are the turreted C. Henry Kimball residence, in the left center, and the mansard-roofed building on the right. Both houses still exist. The former Kimball residence has since been restored, and the mansard-roofed house has been slightly modified.

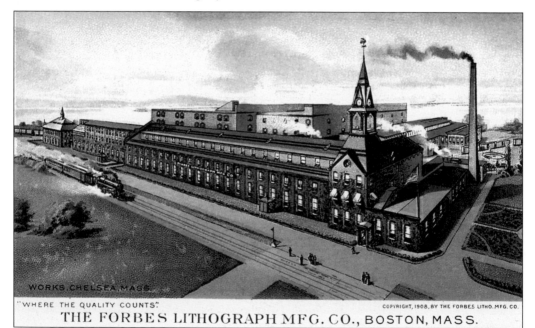

"WHERE THE QUALITY COUNTS." COPYRIGHT, 1908, BY THE FORBES LITHO. MFG. CO.
## THE FORBES LITHOGRAPH MFG. CO., BOSTON, MASS.

**The Forbes Lithograph Manufacturing Company.** This postcard was published by the company in 1908. The factory was on the main line of Eastern Railroad's North Shore-to-Boston route. By 1930, the Forbes complex involved 18 buildings and employed more than 1,000 people. During World War II, the firm produced "invasion scrip" currency for Allied troops of occupied countries. The building still stands, although without the bell and clock tower.

**THE NEW MOUNT BELLINGHAM METHODIST EPISCOPAL CHURCH.** This *c.* 1910 view shows the church that replaced the burned one. The postcard's title describes the church's location as Bellingham Hill, or Mount Bellingham. Bellingham Hill was the smallest of the five hills dotting Chelsea and Revere. Standing at 110 feet above sea level, it afforded one a great view of Boston. In the 1850s, an observatory was located there and, in the 20th century, two hospitals—Frost and Chelsea Memorial.

**THE NEW CENTRAL CONGREGATIONAL CHURCH.** Seen here *c.* 1911 is the rebuilt church, located on the same site as its predecessor. The dedication took place in 1909, about a year after the fire. In 1946, the building was purchased by the Salvation Army. Today, the First Congregational Church serves the Congregationalists of the area.

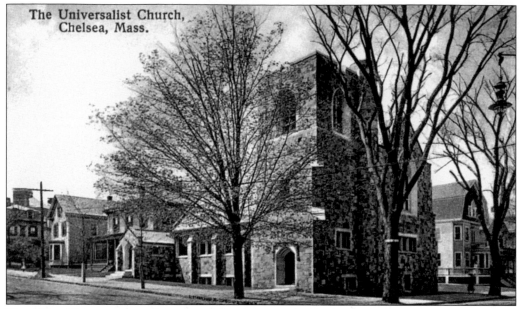

The Universalist Church, Chelsea, Mass.

**THE NEW UNIVERSALIST CHURCH.** After the original church was destroyed in the great fire of 1908, its replacement was built at the corner of Clark and Cary Avenues. The new church, also known as the Church of the Redeemer, was built largely through the efforts of Rev. Perry Bush. He served as pastor until retiring in 1922. He died four years later. The church stood at this location until 1969, when it was demolished to make way for apartment housing.

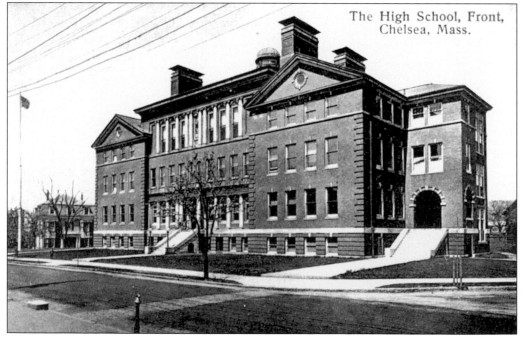

The High School, Front, Chelsea, Mass.

**THE NEW HIGH SCHOOL.** This building, dating from 1904, was located on Crescent Avenue and Tudor Street. It was built on land purchased by the city that was previously the James Tent and Mary Haskell estates. The view shows the school prior to the 1926 addition. After the 1908 fire, the school served as headquarters for the fire relief effort.

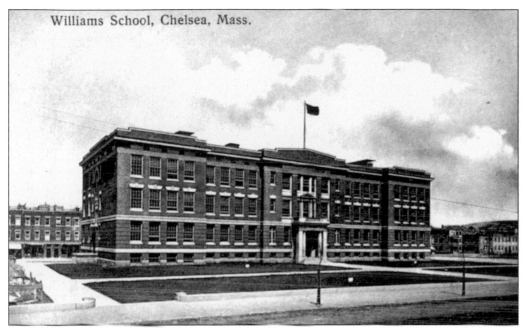

Williams School, Chelsea, Mass.

**THE NEW WILLIAMS SCHOOL.** Replacing the school destroyed in the 1908 fire, this building, pictured c. 1910, was constructed on a large lot at Walnut, Arlington, Fourth, and Fifth Streets. Two additions were made—in 1912 and 1915. The school served the city until the early 1990s, when it was demolished and replaced by a modern building, the Williams Middle School.

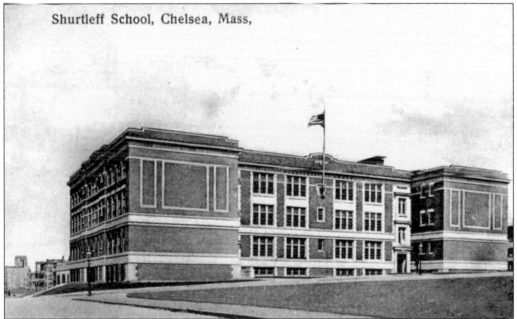

Shurtleff School, Chelsea, Mass,

**THE NEW SHURTLEFF SCHOOL.** Located on land bounded by Central and Congress Avenues and Hawthorne and Shurtleff Streets, the new Shurtleff School was built in 1909. It replaced the old Shurtleff School, which burned in the 1908 fire. Additions to the school were added later. As was the case with the Williams School, the Shurtleff School served the city until the early 1990s, when it was converted to a preschool called the Shurtleff Early Learning Center.

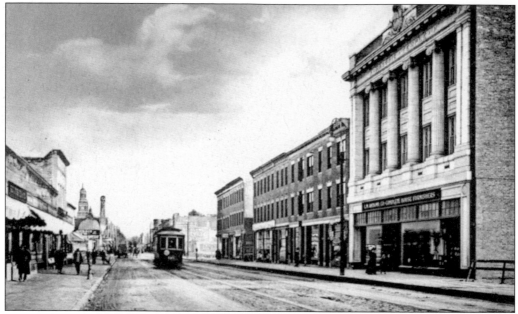

**THE MASONIC TEMPLE AND BROADWAY.** This *c.* 1910 postcard view looks up Broadway toward the new city hall. On the right is the Masonic temple that replaced the one burned in the 1908 fire. Note the electric trolley coming into view.

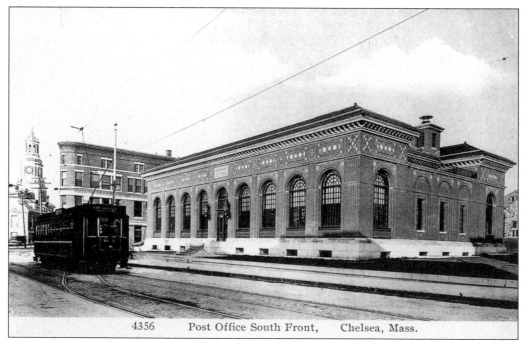

4356    Post Office South Front,    Chelsea, Mass.

**THE NEW POST OFFICE, SOUTH FRONT.** Located in Bellingham Square on Hawthorne Street, the post office was dedicated on July 4, 1910. Among the notable people in attendance that day was Pres. William Howard Taft. This post office served the community until 1992. The building was renovated, and in 1997, it became one of the satellite campuses of Bunker Hill Community College.

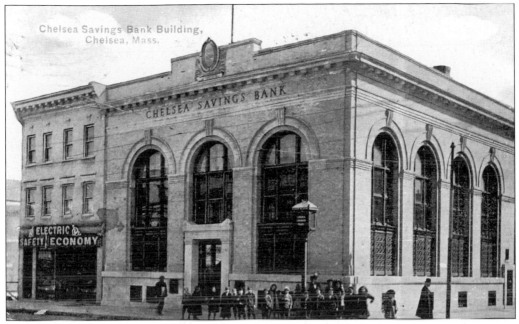

**THE NEW CHELSEA SAVINGS BANK.** This building, replacing the structure destroyed in the great fire of 1908, was located at 267 Broadway, on the corner of Congress Avenue. It advertised convenient operating hours of 8.00 a.m. to 1:00 p.m. during the week, and on Saturday 4:00 p.m. to 8:00 p.m. In 1910, the date of this view, Benjamin Dodge was the bank's president and Albert A. Fickett was its treasurer.

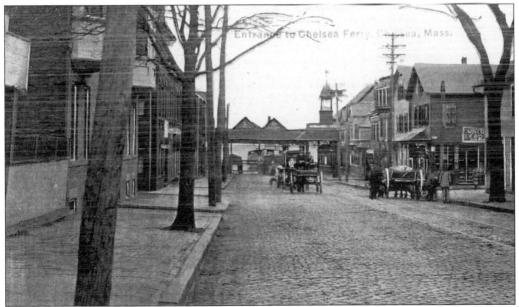

**THE ENTRANCE TO THE CHELSEA FERRY.** A cobblestoned Winnisimmet Street runs toward the Chelsea waterfront, in this *c.* 1910 view. The ferry landing, originally located on the Naval Hospital grounds (now Admiral's Hill), was moved to this location shortly after its establishment in 1631. The ferry was an ultimate casualty of the automobile, streetcar, and other faster modes of transportation. It plied the waters of Boston Harbor for the last time in 1917.

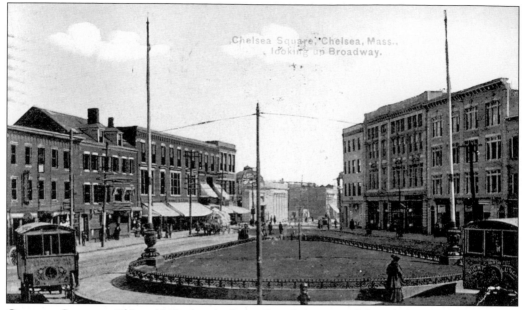

**CHELSEA SQUARE.** This *c.* 1910 view looks up Broadway toward the Chelsea Trust Company. North (now Columbus) Park appears in the foreground. Parked on the south side of the green are two lunch carts, also called dog carts. The portable diners were wheeled out every morning and rolled back at night. They served coffee, sandwiches, and snacks. Prior to the building of the Mystic River Bridge, the dog carts attracted good business from Boston via the old Chelsea North Bridge.

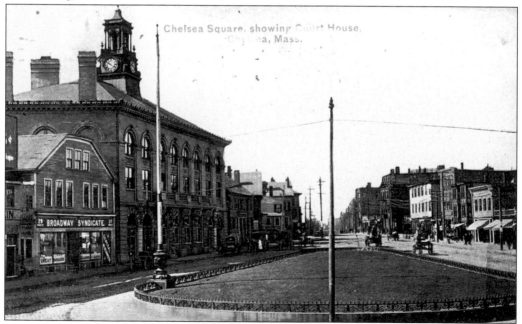

**CHELSEA SQUARE AND THE COURTHOUSE.** Seen in this *c.* 1910 southward view are the district courthouse and police station on Park Street, on the left, and Broadway, on the right. South (now Pulaski) Park is in the foreground. The courthouse was first opened in 1898. The old wooden building to the left of courthouse no longer stands.

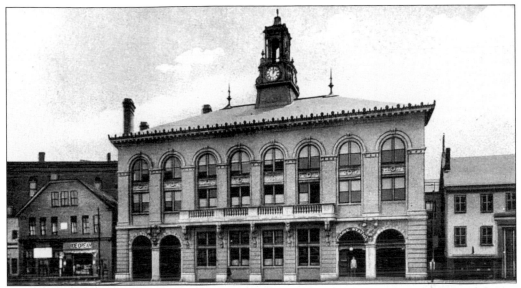

**THE COURTHOUSE.** This well-constructed 1898 building housed the police department, the police court, the overseers of the poor, and a lockup. Its exterior was comprised of buff face brick with a granite and carved limestone trim. The foundation was built of block granite. The city seal was located in the center of the front façade, under the enriched cornice. The roof was covered in red Spanish tiles and surmounted with a clock tower. The floors were constructed of marble, mosaic, and oak.

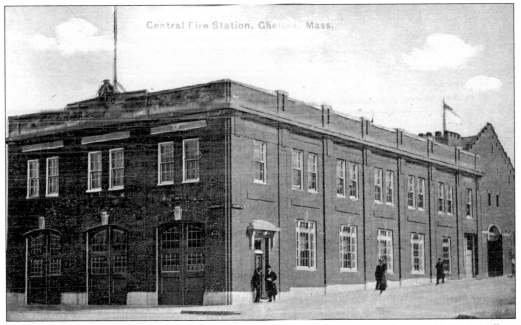

**THE CENTRAL FIRE STATION.** The newly built engine house, seen here c. 1910, is still in operation today. Located at Chestnut Street and City Hall Avenue, it was one of two fire stations erected to replace those destroyed in the great Chelsea fire of 1908 (the other being Engine No. 5 on Everett Avenue). Directly behind the Central Fire Station, part of the new Armory can be seen.

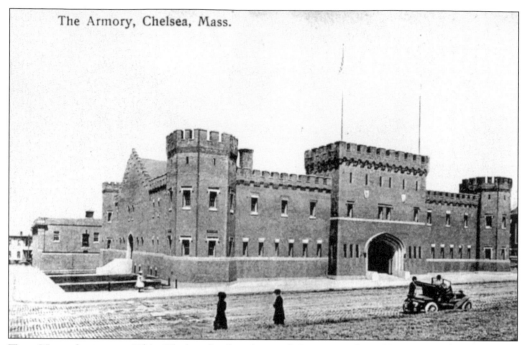

The Armory, Chelsea, Mass.

**THE NEW ARMORY.** This Chelsea landmark stood for more than 50 years at the corner of Armory Street and Broadway. Built after the 1908 fire, it was home to the 5th Company, Massachusetts Volunteer Militia, and later the Battery H, 241st Coast Artillery Regiment. On September 16, 1940, Battery H left for service in World War II. The Armory was destroyed in a May 1952 fire, although the steel framework and brick walls survived. The ruins were not removed until 1957.

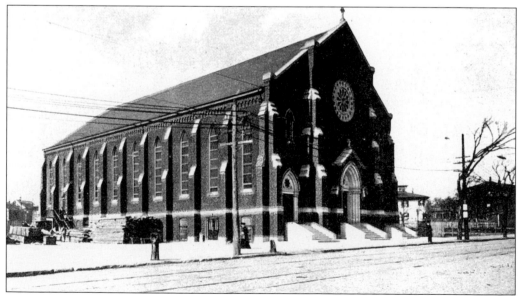

**THE NEW ST. ROSE ROMAN CATHOLIC CHURCH.** Less than a year after the great Chelsea fire of 1908, a new church was built on the same Broadway site. This view shows the newly constructed building and the trolley tracks out front. Note the lumber and construction materials lying beside the church wall.

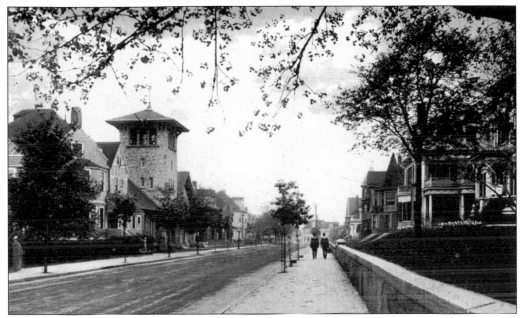

COUNTY ROAD, LOOKING WEST. This c. 1920 postcard depicts a residential area of the city. On the left is the First Congregational Church, formed when several local churches combined: the Broadway, the First (Chestnut Street), and the Third (Reynolds Avenue). The cornerstone was laid in 1906. Completed in 1907, the church still stands after almost 100 years.

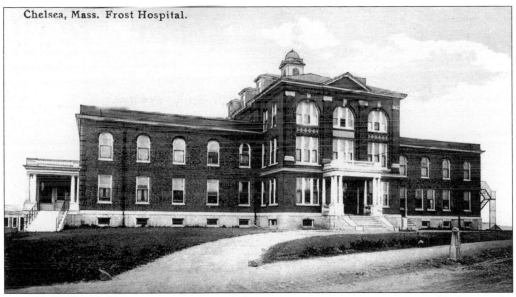

Chelsea, Mass. Frost Hospital.

THE NEW FROST HOSPITAL. Following the 1908 fire, the rebuilding of a hospital began on the top of Bellingham Hill. The first patients were admitted on October 13, 1909. In 1920, the building's name was changed to Chelsea Memorial Hospital. Over the years, the hospital was altered: a nurses' home was constructed in 1923, a children's and accident ward in 1926, and a new wing in 1964. Chelsea Memorial stopped operating on June 30, 1978, and Massachusetts General Hospital assumed operations in 1978, a year after relocating its clinic there. In 1996, Massachusetts General moved to Everett Avenue, ending this building's use as a hospital.

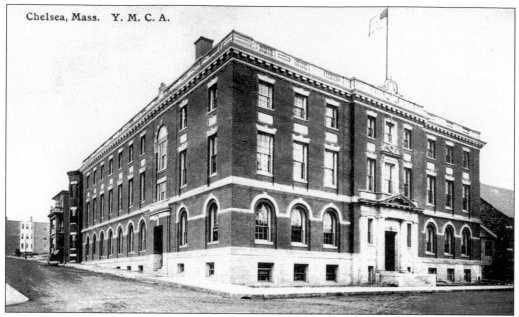

**THE YMCA.** This building was located at the edge of Bassett Square, opposite city hall and the Soldiers' Monument. It replaced the Hawthorne Street structure that was destroyed in the 1908 fire. Today, the YMCA still serves the community at the same location.

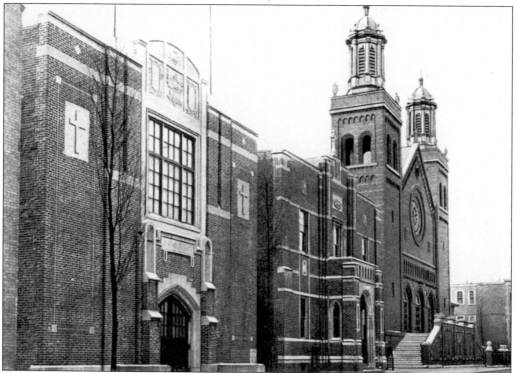

**ST. STANISLAUS SCHOOL, CONVENT, CHURCH, AND RECTORY.** This church was located on the original site of the Winnisimmet Congregational Church. At the time the image was taken, *c.* 1930, the church's address was listed as 165–175 and the school as 181–183 Chestnut Street.

# Five

# THE NAVAL AND

# MARINE HOSPITAL

The U.S. Naval Hospital at Chelsea, located on the present site of Admiral's Hill, was an active military hospital from 1836 to 1974. It was originally located on Essex Street in a three-story building that later houses the old Shurtleff School. That structure was burned in the 1908 fire. The Essex Street site was a marine hospital from c. 1827 to the mid-1850s. A new, larger marine hospital was built on the U.S. government grounds (Admiral's Hill) in 1857, serving from the late 1850s to 1940. During World War II, the building continued to be used by the U.S. Navy. It was closed, along with the Naval Hospital, on June 28, 1974.

Postcards of the U.S. Naval and Marine Hospital in this volume can be divided into three categories: printed views by J. V. Hartman and A. M. Simon, and photographic cards by H. I. Darly and others.

J. V. Hartman produced at least two postcards of the main Naval and Marine Hospital buildings c. 1910. They are typical Hartman views; the images are of excellent quality in composition and clarity.

Two postcards of the Naval Hospital's main entrance are included. One view was by an unknown manufacturer in Germany; the other was a photo postcard by an unidentified photographer. Two other images show the nurses' quarters and the Chelsea Bridge and the new main building.

A. M. Simon of 32 Union Square, New York, created an excellent series of the U.S. Naval Hospital. Based on the postmarks, the postcards were sold from c. 1919 to 1924. The 14 included views constitute two street scenes, the commanding officer's quarters, four exteriors of the main building, two rare interiors—one of a ward, the other of the Red Cross building—a bird's-eye view of the barracks and grounds, the nurses' home, the garage, the powerhouse, and the stairs leading to the summit.

H. I. Darly of Union Square, Somerville, produced a small series of photo postcards c. 1920. Included are six unique views showing a detailed panorama of the Naval Hospital grounds from the Chelsea Bridge: two of the commanding officer's and nurses' quarters and one of the Hospital Corps Club and the new main building.

The highlighted photographers documented in detail the military hospital complex. Other manufacturers produced views, but none approached the sophistication and comprehensiveness of A. M. Simon and H. I. Darly.

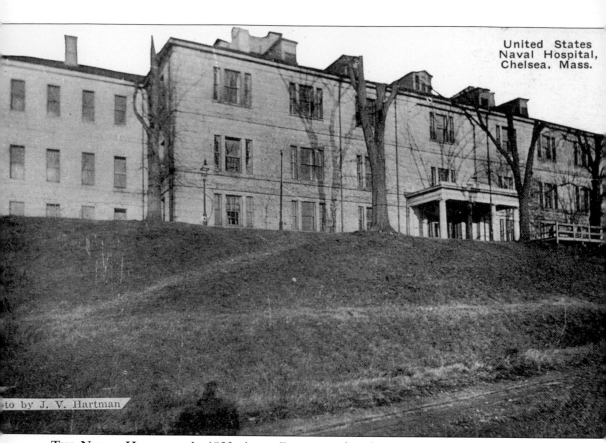

United States
Naval Hospital,
Chelsea, Mass.

to by J. V. Hartman

**THE NAVAL HOSPITAL.** In 1823, Aaron Dexter purchased 115 acres of land bordered by the Mystic and Island End Rivers with the goal of building a larger naval hospital. The previous location, at the Charlestown Navy Yard, was found to be inadequate. In the summer of 1832, when federal funding became available, construction began. The original foundation measured 149 by 71 feet. The hospital was completed and commissioned on January 7, 1836, with a 100-bed capacity. An addition was constructed in 1865. It served as the main naval hospital building on site for almost 80 years. During World War I, it was a nurses' quarters. Today, it houses high-end condominiums.

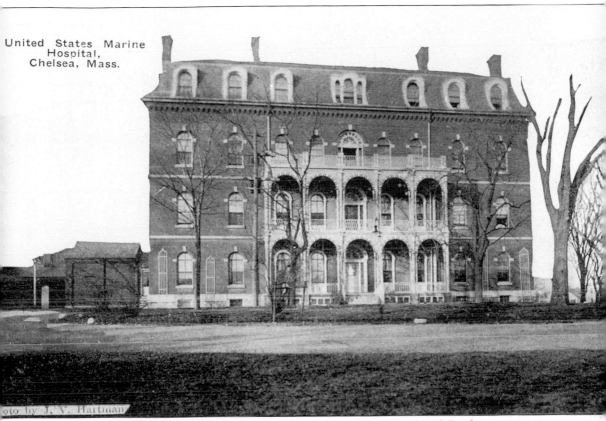

United States Marine
Hospital,
Chelsea, Mass.

oto by J. V. Hartman

THE MARINE HOSPITAL. In 1855, some 10 acres of land were purchased for the construction of a new marine hospital to replace the original 1827 building, located on Essex Street. Two years later, at a cost of approximately $353,452 ($50,000 for the land, $303,452 for the building), the three-story brick structure was completed, with arched windows and wrought-iron doors and window frames. A fourth story was added, along with the familiar mansard roof, in 1866. The slate roof was severely damaged in the 1938 hurricane and was replaced. The Marine Hospital served the city until 1940, when it was moved to Brighton. The Naval Hospital acquired the building in 1942 for conversion into barracks for hospital corpsmen. Today, the 147-year-old building is an apartment complex.

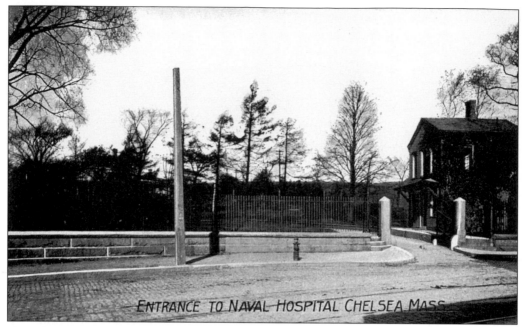

**THE NAVAL HOSPITAL ENTRANCE.** The old entrance on lower Broadway is pictured here *c.* 1910. The old guardhouse can be seen just inside the entrance. The trolley ran in this section of Broadway, as evidenced by the tracks on the lower right. The number of trees on the U.S. government grounds gives a peaceful serenity to the scene.

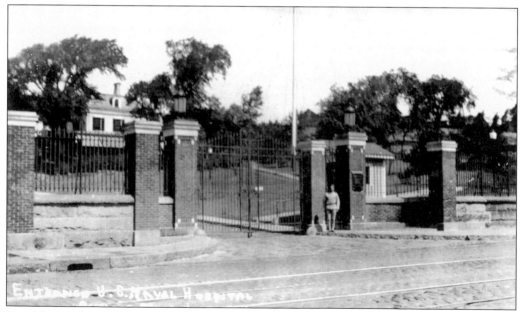

**THE NAVAL HOSPITAL ENTRANCE.** Dated July 1924, this photograph shows a guard posted outside the new gated entrance. The guardhouse can be seen to the right, inside the closed gate. Part of the commanding officer's quarters is visible through the trees.

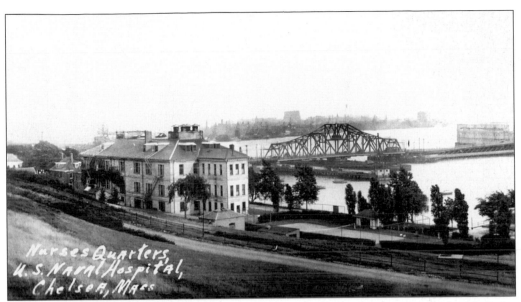

**THE NURSES' QUARTERS.** Taken from the hillside of the U.S. government grounds, this image shows the back of the 1836 Naval Hospital building and the Chelsea Bridge. At the time the photograph was taken, c. 1920, the granite structure served as living quarters for the nurses on site. The 1865 wing addition is clearly visible. The rarely seen predecessor to the Mystic River Bridge, the Chelsea Bridge, is shown here, connecting Chelsea and Charlestown.

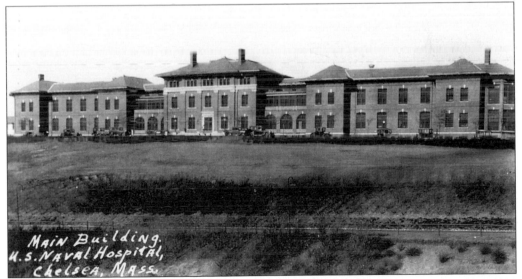

**THE MAIN BUILDING.** During World War I, the Chelsea Naval Hospital was enlarged to 1,000 beds to accommodate the sick and wounded. At the end of the war, the temporary additions were removed and the hospital returned to its prewar role of serving the First Naval District. The large number of cars parked out front of the building indicates the automobile was truly coming of age c. 1920.

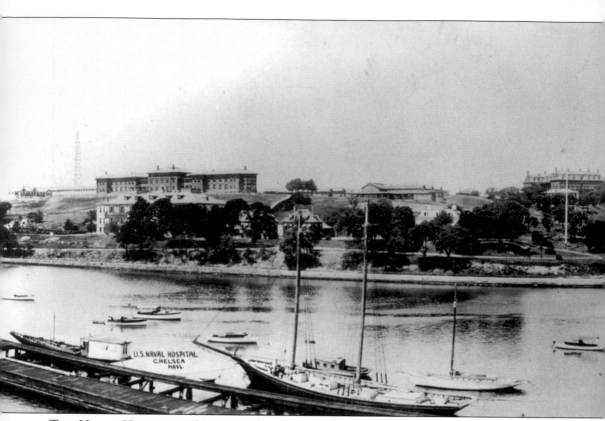

**THE NAVAL HOSPITAL.** This wonderful panorama was taken from the Chelsea Bridge *c.* 1920. It offers a perspective of the building locations on the U.S. government grounds at the time. Starting on the summit are, from left to right, the Hospital Corps Club, the radio-receiving tower, the new Naval Hospital building (on the summit), some barracks, the Red Cross building, and the Marine Hospital, with the mansard roof. Below the new Naval Hospital building are, from left to right, the nurses' quarters (the old Naval Hospital), two captain's houses, and the commanding officer's quarters, all partially obscured by broadleaf trees along the base of the hill.

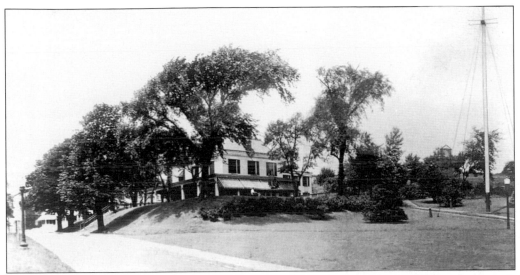

**THE ENTRANCE AND QUARTERS.** This idyllic scene *c.* 1920 is reminiscent of a simpler time. It shows a medium-close view of the commanding officer's quarters, with its awnings fully engaged, likely on a hot summer day. To the left of the flagpole, protruding above the trees, is the top of the water tower. The 150 foot tower held 100,000 gallons of water and stood over the Naval Hospital for many years until being torn down in February 1980.

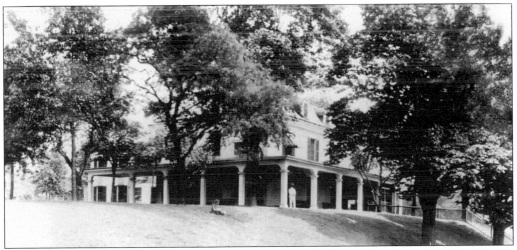

**THE COMMANDING OFFICER'S QUARTERS.** The officer standing in front of the building *c.* 1920 may be the commandant. Sitting on the small hillock out front is a young girl, possibly his daughter, who appears to be enjoying the peaceful surroundings.

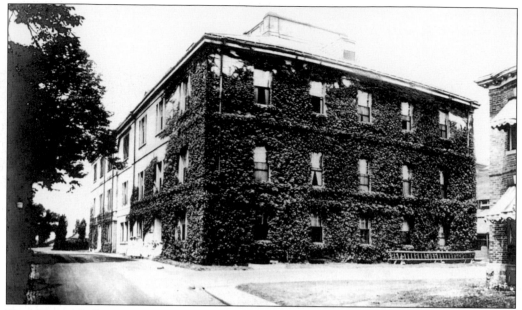

**THE NURSES' QUARTERS.** Previously housing the old Naval Hospital, the granite building is covered with ivy in this *c.* 1920 H. I. Darly photograph. Standing on historic ground, the structure was, and still is, "a stone's throw" from the locations of two early Chelsea landmarks: the first house built in the Massachusetts Bay Colony (1625) and the first ferry landing in North America (1631). On the right is the corner of one of the two captain's houses (with awnings).

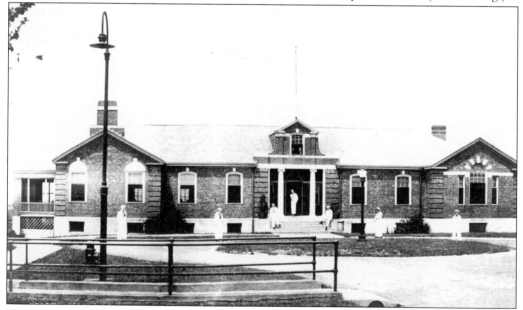

**THE HOSPITAL CORPS CLUB.** The red brick building was formally opened on May 4, 1920. Also known as the White Hat Club, it served as a social club and memorial for the men of the hospital corps of the U.S. Navy during World War I. Erected and furnished by the Knights of Columbus, the club housed a gym, a swimming pool, a dressing room, a lounge, showers, a library, a clubroom, and a billiard room. Two plaques commemorating the corpsmen who served in the Great War were displayed on site.

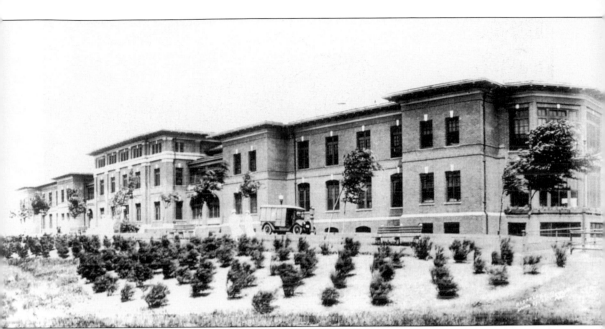

**THE MAIN BUILDING.** The Naval Hospital building, seen here *c.* 1920, stood on the summit of the Naval Hospital hill. Constructed and commissioned on April 24, 1915, the hospital played a key role in caring for military patients struck by the great influenza epidemic of 1917–1918. The epidemic necessitated a ninefold increase in doctors and a fourfold increase in the nurse corps at the Naval Hospital. Even with the extra medical personnel, the hospital could not take care of all the sick. Many were diverted to Boston hospitals. By the time the epidemic had run its course, 30,000 army and navy personnel had died worldwide. The Naval Hospital was closed down in 1974, during the administration of Pres. Richard M. Nixon. The building was then demolished in the 1980s to make way for modern housing.

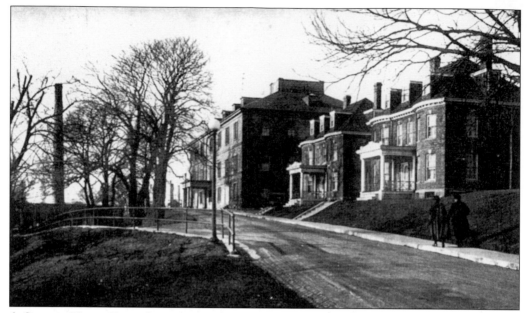

**A STREET VIEW.** From the U.S. Naval Hospital's main entrance, the winding driveway led up past the commanding officer's quarters. There, several buildings came into view. On the left, the smokestack of the powerhouse is visible through the leafless trees. The nurses' home (the old Naval Hospital) is in the center, and the captain's houses are on the right. Two warmly dressed women travel by foot, likely to their dormitory rooms at the nurses' home.

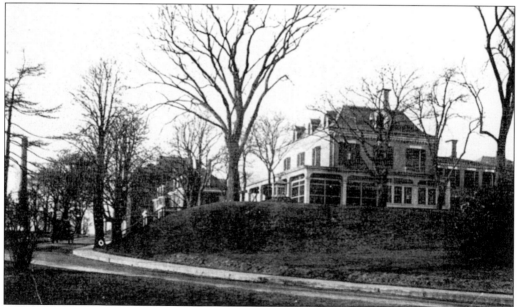

**THE COMMANDING OFFICER'S QUARTERS.** Built in 1856, this two-story building has gone through numerous repairs. A 1917 fire during renovations did considerable damage. The building had some notable features, including a mansard roof forming a third floor. A columned veranda wrapped around the front and sides of the building, and a side was enclosed with windows. A two-story addition with a pitched roof was attached in the back, housing the kitchen and some second-floor living space.

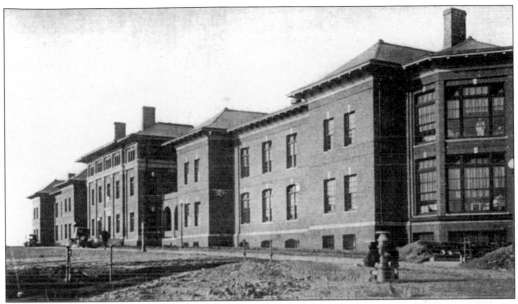

**THE MAIN BUILDING.** This image shows the *c.* 1913 main building, also known as Building 22, on the hill's summit. The structure served as the Naval Hospital from 1915 to 1974. A veteran peers out of the large window on the upper floor at the right.

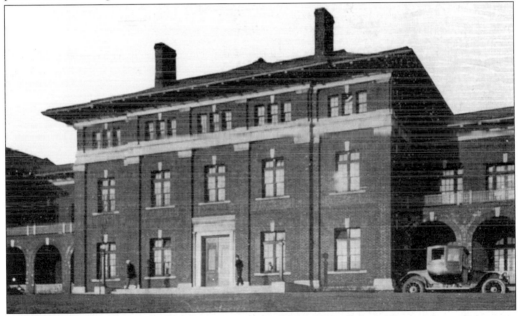

**THE ENTRANCE TO THE MAIN BUILDING.** Building 22 had three floors, plus a basement. At basement level were the admissions office, emergency room, main X-ray lab, ear-nose-throat-and-eye clinic, laboratory, male-screening clinic, physical examination room, and kitchen. On the first floor were the dining room, offices of the commanding and executive and adjutant officers, information and officer-of-the-day desk, and Wards A, C, E, and G. On the second floor were the intensive care unit, main operating room, plastic surgery and surgical clinic, and Wards D, B, F, and H. On the third floor were the medical library, the "SOQ" medical, and the surgical wards.

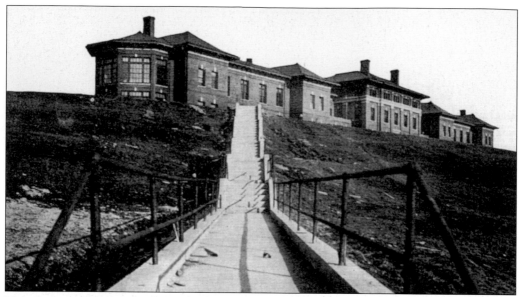

**THE STAIRWAY TO THE MAIN BUILDING.** One of the main attributes of the Naval Hospital site was its commanding view of the Mystic River and Boston Harbor. The summit measured 112 feet above sea level (138 feet according to Pratt's history). Consequently, a stone stairway was built from the base to the summit of the hill to accommodate foot traffic to and from the main building. The stairway was removed in the early 1980s to facilitate the development of Admiral's Hill.

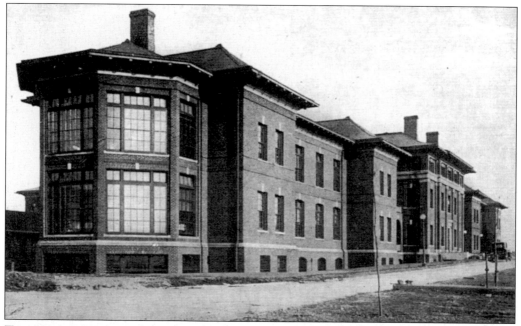

**THE MAIN BUILDING.** Showing the right side of hospital, facing Boston, this image records the expanse of the structure. Following the decision to close the Naval Hospital in 1974, a study was conducted to determine the feasibility of restoring it into living space. The study concluded that the building's configuration was irregular in shape and would not allow enough privacy as apartments. This resulted in the building's demise, culminating in its razing in the early 1980s.

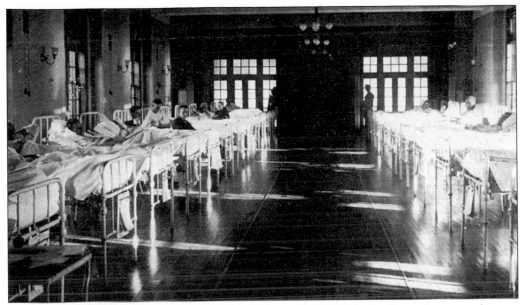

ONE OF THE WARDS. This rare interior view of the main building shows servicemen convalescing shortly after the end of World War I. Over the years, many patients passed through the doors of the Naval Hospital. The most famous was a 27-year-old ensign named John F. Kennedy. Because of wounds received from the sinking of his patrol boat, *PT-109*, Kennedy spent more than six months recuperating at the Naval Hospital—from June 11, 1944, to December 26, 1944.

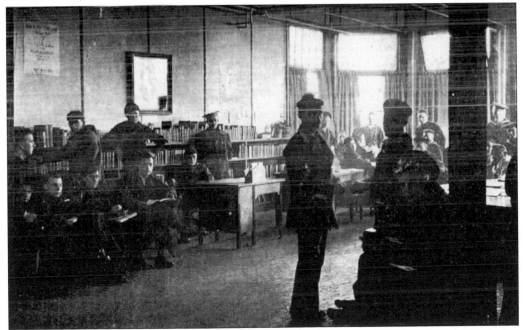

THE RED CROSS BUILDING INTERIOR. Located to the left of the main building, when facing the water, the Red Cross building, also known as Building 55, dates from *c.* 1915. In this *c.* 1920 view, taken inside the Crews Library, veterans of World War I relax. The building existed until the early 1980s.

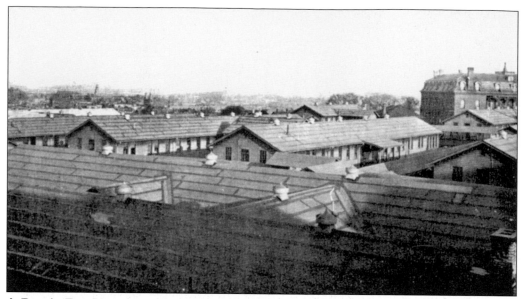

**A Bird's-Eye View of the Naval Hospital.** Likely taken from the main building on the summit, this view looks across some well-constructed barracks, built during the early part of the century, and part of the Marine Hospital. The U.S. Marine Hospital building was designed by local architect Ammi B. Young. The edifice housed 140 patients when it opened in 1857. At the time, it cost approximately $20,000 to run the facility. Some 90 percent of the expense was covered by money collected from seamen.

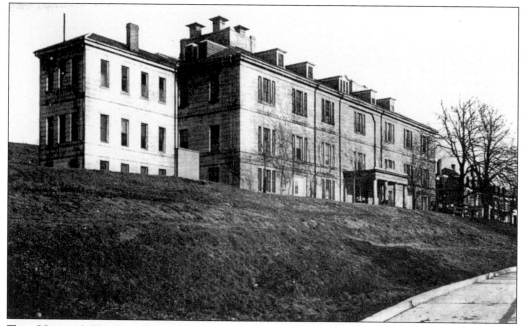

**The Nurses' Home.** The old Naval Hospital building was commissioned and occupied on January 7, 1836. This view, taken at street level, shows the hillock upon which the structure was built. The portico over the front entrance is clearly visible. That feature has since been removed. A change to the original building not previously mentioned was the 1903 addition to the north end.

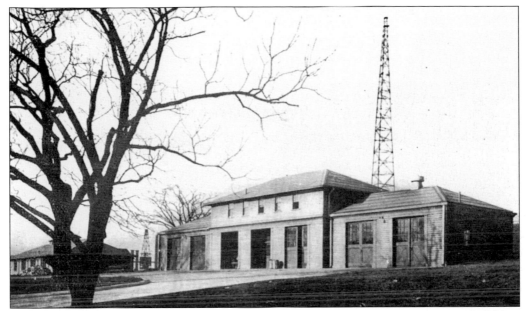

**THE GARAGE.** The U.S. Naval Hospital was a city within a city. That fact required maintenance services to be performed on the premises. This c. 1920 view shows the garage, located at the base of the hill, to the right (when facing the water) of the old Naval Hospital building. Also visible is the radio-receiving tower, in service until 1925. The garage was a casualty of the development of Admiral's Hill in the 1980s.

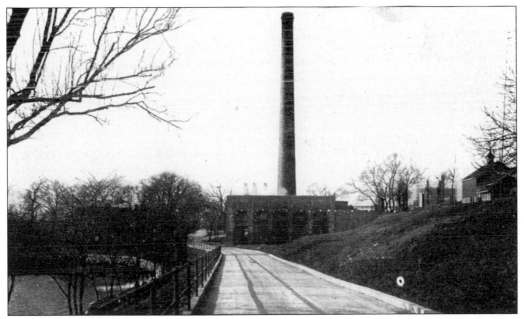

**THE POWERHOUSE.** Seen here c. 1920, the powerhouse was located near the water's edge, just below and to the right (when facing the water) of the old Naval Hospital building. It, too, was demolished to allow for the development of Admiral's Hill.

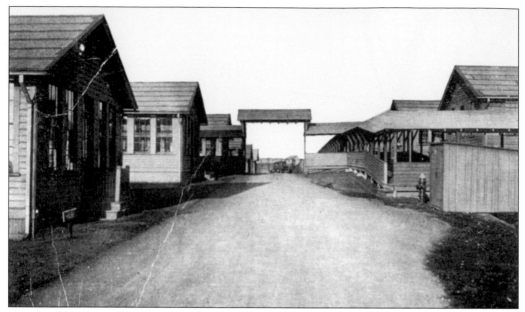

**NAVAL HOSPITAL BARRACKS.** The barracks were situated on the summit adjacent to and behind the main Naval Hospital building. Likely erected during World War I, the housing accommodated the rapid rise in population of servicemen stationed on site.

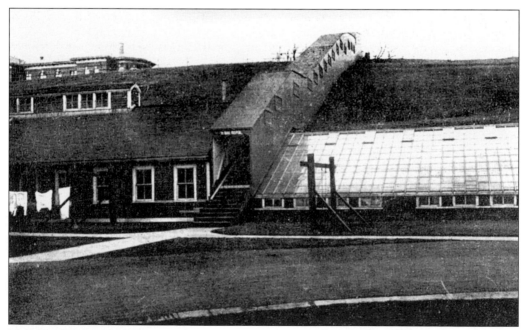

**THE STAIRS TO THE NAVAL HOSPITAL.** A second set of stairs connected the base of the hill and the main building on the summit. This *c.* 1920 view shows the stairs and the enclosure that protected soldiers and sailors in all types of weather. Part of the new Naval Hospital building can be seen in the upper left. Someone is taking advantage of the dry weather, as evidenced by the laundry hung on the clothesline on the left.

# Six
# PRATTVILLE

Today, Prattville is a residential section of the city, north of the Revere Beach Parkway. It has a long, varied history. Chelsea at one time was divided into two sections: Ferry Village and Prattville. The latter was named for the Pratt family, one of the first to settle in this part of the city. In 1695, Lt. Thomas Pratt purchased from Aaron Way and William Ireland what later became known as the Way-Ireland Farm. The land, about 200 acres, had previously been acquired in 1637 by Sir Henry Vane, governor of the Massachusetts Bay Colony. After his return to England, the land was sold several times before it was bought by Pratt. Two homes existed on the property at the time of purchase. The first was the c. 1675 Way house, located where Harvard and Fremont Streets meet. This structure was modified by Lieutenant Pratt, and it eventually became known as the Pratt Mansion House. The second was the Ireland house, believed to be the old Pratt House, located on Washington Avenue, set back from the road near Lambert. The Pratts lived in this section of the city into the 20th century. As a result, seven generations of Pratts witnessed more than 200 years of American history.

In general, postcards of Prattville are not common. The few photo postcards included, printed between 1905 and 1913, do not have a photographers' imprint. They highlight the important sites and streets including Washington Park, Washington Square, Nichols Street, the Prattville School, and Harvard Street. The print quality varies from good to excellent.

The Robbins Brothers Company and Reichner Brothers of Boston and Germany each published a c. 1908 view of the Prattville School. Their print quality is excellent.

C. W. Freeman, a Chelsea druggist, published a bird's-eye view of Prattville and a scene of the old Pratt House. The postcards are well detailed and date from c. 1913. Other publishers produced views of Washington Square and the Our Lady of Grace Church and School. Herbert M. Siegel produced a multiview postcard of Prattville landmarks in 1962.

Fortunately, the small numbers of available postcards contribute to the visual record of this historic area.

*Give my regards to your Papa and Mamm... This is one of the few pret... places ... Chelsea. I know I owe you ... a letter, but I should like to hear fr... you. Chick...*

**WASHINGTON PARK.** Taken from inside the park, this 1906 view looks down toward Washington Square. The land on which the park was built served as a poor farm until the 1850s. Bounded by Washington Avenue and Franklin, Hancock, and Warren (now Nichols) Streets, the site was first proposed as a park by Caleb Pratt, a Chelsea city councilman. During this time, the proposed parkland became a dump. After several unsuccessful attempts to obtain park status, Pratt's son Hermon Washington Pratt was elected to the city council and continued his father's wish. His doggedness paid off, and the city set aside the land. Victory could not be declared, however, as funding was unavailable for beautifying the lot. Only through the Hermon W. Pratt's personal fund-raising efforts was enough money collected to support the project. On July 4, 1887, Washington Park was officially dedicated. Known today as Prattville Park, it is a venerable landmark of the city.

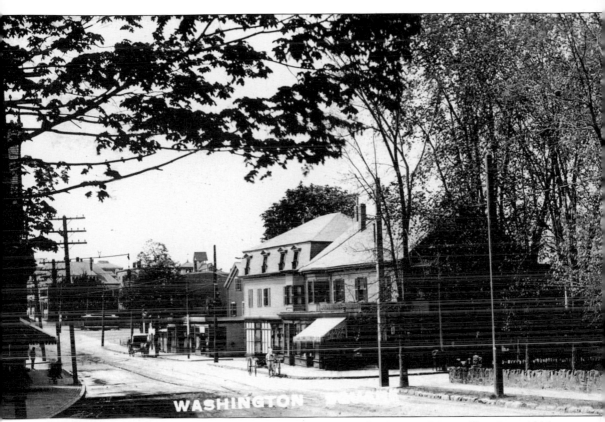

WASHINGTON SQUARE

**WASHINGTON SQUARE.** This photograph was taken in the heart of Prattville. A *c.* 1913 southward view, it looks up Washington Avenue toward the Revere Beach Parkway. Near the parkway, an electric trolley leaves the carbarns. In the distance on the right side of the road near the top of the tree line is the roof of the First Congregational Church, on County Road. Toward the square is a small rectangular building that housed Sam Sarcias Shoe Repair for many years. Today, it is a beauty salon. Farther up on the right side of the road is a block of wooden buildings that housed W. A. Perkins, Druggist. In the 1950s and 60s, the Prattville Pharmacy was located in a modern building on the site. That gave way to a newer building for the Metropolitan Credit Union in the 1970s and 1980s. A pizza parlor and donut shop are now located there. In the right foreground is part of Washington Park, created in 1887.

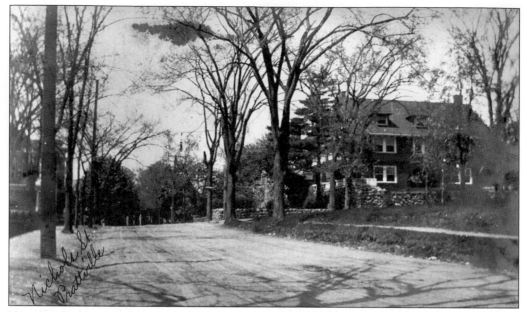

**NICHOLS STREET.** Taken just outside the north wall of Washington Park, this *c.* 1910 view looks westward. On the right, at Nichols and Franklin Street, is Hermon W. Pratt's home, which incorporated parts of the old Pratt Mansion. In the 1950s, the Our Lady of Grace parish purchased it, converting it into a convent for the Sisters of St. Joseph. Today, it is the Don Guanella Respite, run by the Sisters of Mary of the Divine Providence.

**PRATTVILLE.** This westward view of Washington Avenue *c.* 1913 reveals an undeveloped area of Prattville. From left to right are the Washington Park entrance and Hermon Washington Pratt's house, the latter mostly obscured by trees. The partial view of the white house shows Dr. Nalchajian's former residence. The wooden fence on Eustis Street borders the Old Ladies' Home, just out of view to the right. During the American Revolution, troops of Colonel Gerrish's regiment were quartered in the vicinity.

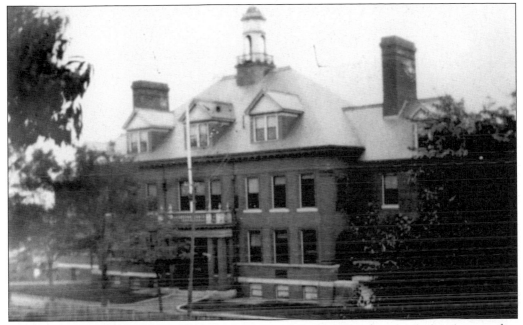

**THE PRATTVILLE SCHOOL.** According to the plaque displayed on the school, the photographer of this c. 1905 image was standing on historic ground: the former site of the Pratt Homestead (Mansion House). Gen. George Washington was entertained at the home in 1775 while inspecting Colonel Gerrish's troops. No known photographs of the house exist, as it was demolished in 1855. The house's doorstep was saved and built into the north wall of Washington Park.

**HARVARD STREET.** In this c. 1911 view toward Everett, a number of fine homes make up a Prattville neighborhood. C. A Campbell, a local executive in the shipping and coal business, boarded at 77 Harvard Street in 1901, before moving to Ipswich. Many of the homes in this view remain.

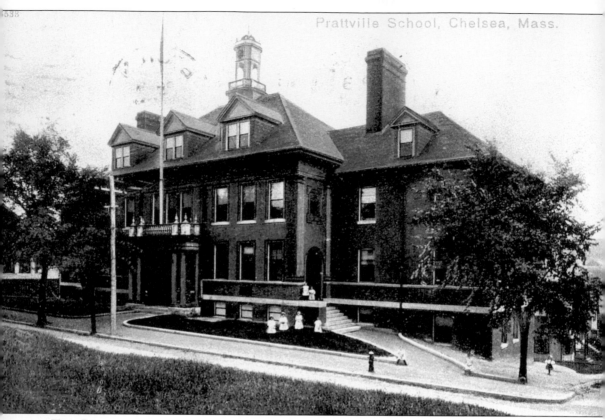

**THE PRATTVILLE SCHOOL.** On September 25, 1897, at 3:00 p.m., Mayor Hermon W. Pratt laid the building's cornerstone. Present at the event was Mellen Chamberlain, who served as main orator. Chamberlain, a judge and historian, later wrote the scholarly two-volume *History of Chelsea*. Several artifacts of local historic interest were placed in a time capsule beneath the cornerstone. Among the items were a door panel from the Pratt Homestead (Mansion House), a program from the recent dedication of the Winnisimmet Parkway, copies of several Chelsea newspapers, a 25-shilling piece of Continental money dated 1773, and a piece of the frigate *Constitution*. A school tablet was inscribed with facts regarding Prattville's important role in the country's early history and its contributions during the American Revolution.

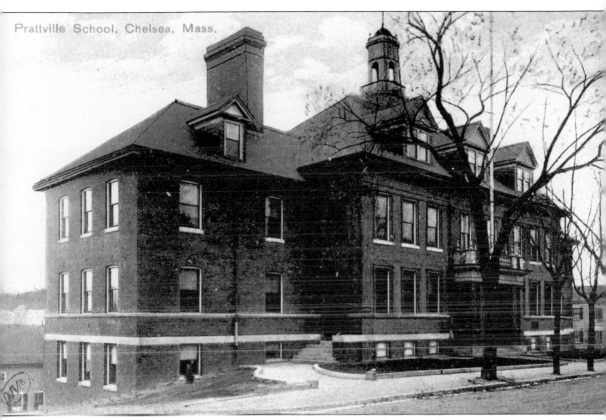

Prattville School, Chelsea, Mass.

**THE PRATTVILLE SCHOOL.** This charming building, located on Washington Avenue and bordered by Ingleside Avenue and Murray Street, was built by architects Wilson and Webber, who also constructed the Highland School, at Cottage and Highland Streets. The Highland School building was later destroyed in the great 1908 fire. The Prattville School, however, served as a school until 1996. It has since been completely refurbished and is currently a condominium complex.

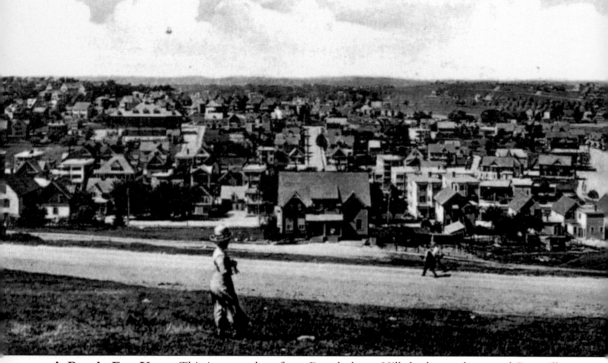

Bird's-Eye View Prattville, Chelsea, Mass.

**A BIRD'S-EYE VIEW.** This image, taken from Powderhorn Hill, looks north toward Prattville and beyond to Revere. On the far left horizon, homes dot the east side of Mount Washington, formerly known as Sagamore Hill. On the right, the back of the Prattville School is clearly visible, with Ingleside Avenue bordering the right side of the building. The street (hill) in the center is Lambert Avenue. Just to the right, at the hill's top and hidden by trees, is the old Pratt House. On the far right is a newly laid-out Garfield Avenue. Above Garfield Avenue and to the left is a mostly undeveloped Cow Hill. This image dates from 1905, but the card was issued later, *c.* 1913.

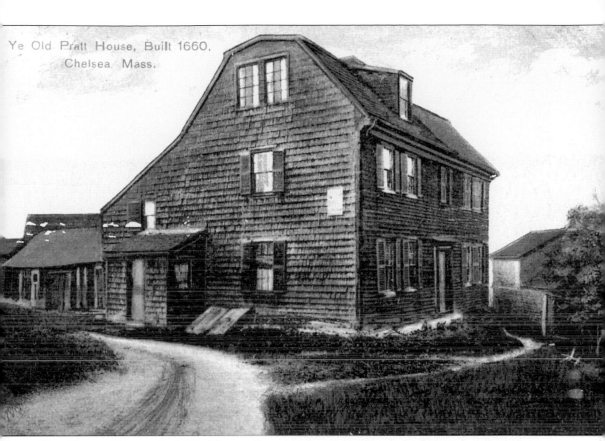

Ye Old Pratt House, Built 1660, Chelsea, Mass.

**THE PRATT HOUSE.** In 1695, Thomas Pratt purchased the Way-Ireland Farm, starting an over-200-year reign of the Pratt family in Chelsea. This historic house was located on Washington Avenue, set back from the road, near Lambert Avenue. The house was built sometime between 1660 and 1700. Up to the early 1900s, a Pratt family member always resided here. In June 1900, Rebecca Pratt, the daughter of a Revolutionary War soldier, died in the house. At the time the photograph was taken, the house was the second oldest in the city. It survived into the 20th century, but unfortunately, its years were numbered. According to city records, the house was demolished on September 30, 1953. A search of newspaper accounts of the time sadly showed no evidence of a public outcry in the months leading up to the demolition. Today, several homes occupy the site.

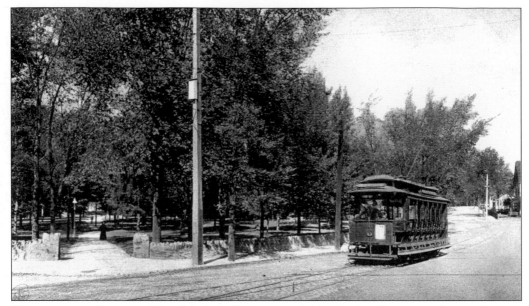

**WASHINGTON SQUARE.** The electric trolley was a popular mode of transportation at the time this postcard was issued, *c.* 1907. The open car travels on Washington Avenue, heading toward the Revere Beach Parkway and the carbarns. Up the walkway on the left, Washington Park is at its finest, with the trees in full foliage. Straight up behind the trolley are Eustis Street and a partial view of the Old Ladies' Home (right).

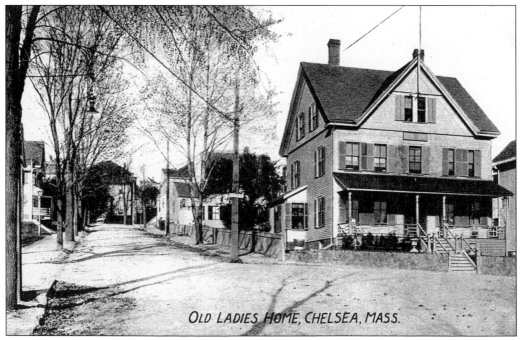

OLD LADIES HOME, CHELSEA, MASS.

**THE OLD LADIES' HOME.** This view dates from 1923. Located in Washington Square at the junction of Nichols and Eustis Streets, the residence was opened on January 1, 1887. Over the years, it was primarily used as housing for elderly women. Today, it functions as business offices for a fire insurance firm and as a private residence.

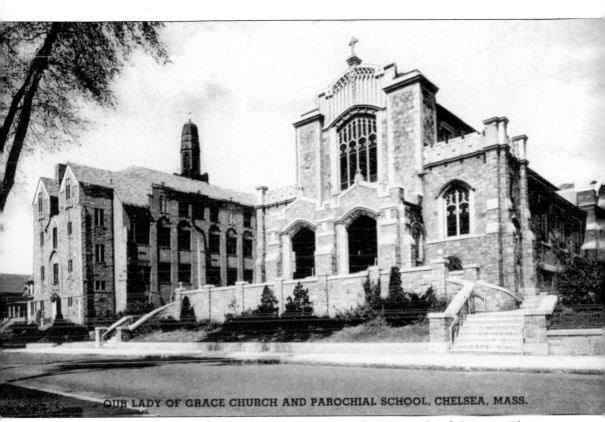

OUR LADY OF GRACE CHURCH AND PAROCHIAL SCHOOL, CHELSEA, MASS.

**THE OUR LADY OF GRACE CHURCH AND SCHOOL.** The Our Lady of Grace parish was established in 1913 to accommodate the growing Catholic population in Chelsea and Everett. Initially, Mass was celebrated in the Prattville School Hall for six months and, afterward, in a temporary structure located next to the present rectory on Nichols Street. The church cornerstone was laid on August 5, 1916, and the completed building was dedicated on May 20, 1917. In 1927 the decision was made to build a school on adjacent land, given as a gift by the treasurer of Atwood and McManus. Construction of the school was initiated in 1927 and completed two years later. The Sisters of St. Joseph ran the school for many years.

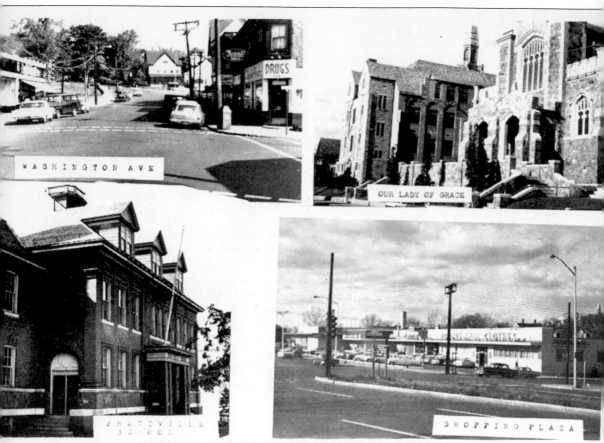

**Scenes of Prattville, Chelsea, Mass.**

SCENES OF PRATTVILLE. The major landmarks of Prattville are shown in this *c.* 1962 multi-scene chrome postcard. In the upper left is Washington Avenue. Visible in this northward view are Washington Park (far left), the Old Ladies' Home (straight ahead), and two area drugstores —the Prattville Pharmacy, at the corner of Hancock Street (left center), and the Sagamore Pharmacy, at the corner of Sagamore Avenue (right center). The Prattville Pharmacy was razed to make way for the Metropolitan Credit Union, operating during the 1970s and 1980s. Today, a Dunkin' Donuts and a Pizza Lovers are located in the former bank building. The Sagamore Pharmacy currently houses a Prattville Pizza and Restaurant. In the upper right is the Our Lady of Grace Church and School. In the lower right are the shopping plaza and Robert Halls Clothes. The clothing store, located where Washington Avenue meets the Revere Beach Parkway, was in business until *c.* 1970. In the lower left is the Prattville School, which served local area students at the elementary level.

# Seven
# THE SOLDIERS' HOME

Having witnessed the dissolution of a home for veterans in Roxbury in 1870 due to insufficient funds, Gen. Horace Binney Sargent was determined to persevere in the establishment of a soldiers' home in Massachusetts. The idea of building one was born at a meeting attended by Sargent and other war veterans. The conference took place on June 18, 1875, the 100th anniversary of the Battle of Bunker Hill. As department commander of the Grand Army of the Republic (GAR), Sargent worked diligently to build a veterans' home. However, it took six more years to fund the project, which involved purchasing land and building a structure. In 1881, the GAR Board of Trustees bought the bankrupt Highland Hotel, atop Powderhorn Hill in Chelsea. The location was appropriate for two reasons: it had served as an encampment for soldiers in the Revolutionary War, some of whom later participated in the Battle of Bunker Hill, and it was where wounded soldiers were treated after the battle. Finally, in 1882, the Soldiers' Home was dedicated as a home for Civil War veterans.

The Soldiers' Home was fairly well documented in postcards. However, photographic postcards of the pre–World War I era are not common. Two without a photographer imprint are included, one showing the newly built Adams Hospital and one multi-scene view of the buildings in the hospital complex. Also during this time, two other publishers issued views of the main buildings and driveway: druggist C. W. Freeman and the New England News Company of Boston.

Roland A. Moore of Weston produced at least five views of the Soldiers' Home including the main drive, two of the Adams Building, one of the nurses' home, and one of the dormitory, all c. 1950. Tichnor Brothers of Boston published a small number of linen cards of the Quigley Memorial Hospital c. 1957.

Although few chrome postcards of Chelsea were produced, several exist of the Soldiers' Home. The included views show the Administrative and Adams Building, the Quigley Memorial Hospital, and a nice interior of St. Michael the Archangel's Chapel.

Overall, photographers recorded in good detail the changes to the Soldiers' Home during the 20th century. Further searching will undoubtedly uncover views of less-photographed subjects including the water tower, Malone Park, and building interiors.

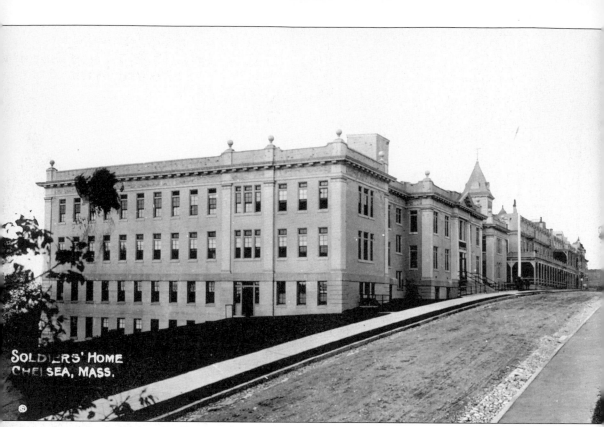

SOLDIERS' HOME
CHELSEA, MASS.

**THE CAPT. JOHN G. B. ADAMS HOSPITAL.** In an ongoing attempt to improve the safety conditions on site, the state allocated $250,000 for the construction of a separate fireproof hospital on Crest Avenue. Named the Adams Hospital, the building was erected adjacent to the original wooden hospital on Powderhorn Hill. The Adams Hospital was outfitted with modern equipment and was adequately funded to hire a sufficient work force.

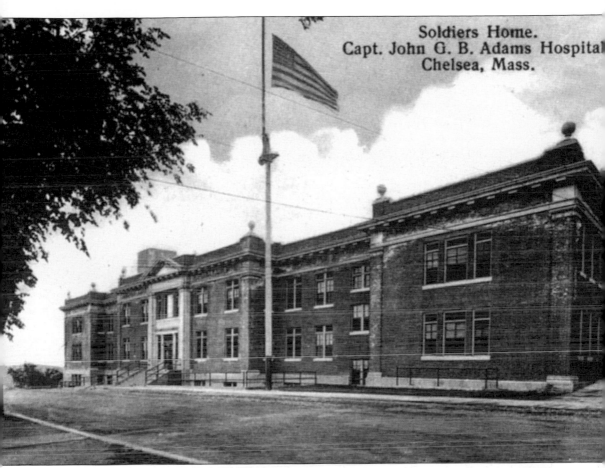

Soldiers Home.
Capt. John G. B. Adams Hospital
Chelsea, Mass.

THE CAPT. JOHN G. B. ADAMS HOSPITAL. The building, opened and occupied in 1909, was named for the second vice president of trustees. Also serving as president in 1883 and 1004, John G. B. Adams championed the cause for establishing additional hospital space to house more veterans. While president, he rallied the public to remember the veterans by donating "what they could" at the Soldiers' Home Carnival, held in the Institute Building, in Boston, on April 7, 1885.

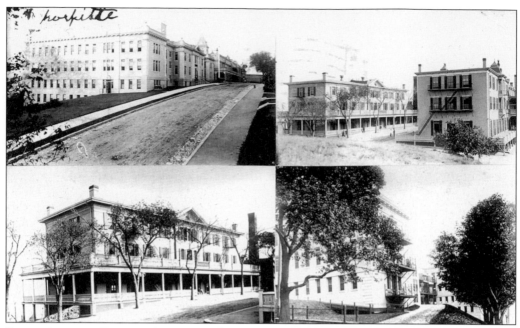

**SCENES OF THE SOLDIERS' HOME.** This rare multi-scene postcard, *c.* 1915, shows the major buildings on site. In the upper left, along Crest Avenue, are the Adams Hospital and the old wooden building. In the upper right are Sargent's Hall (left), plus and a building annex, and the old Soldiers' Home. In the lower right is the back of the Soldiers' Home, along a tree-lined Hillside Avenue. In the lower left is Sargent's Hall—a nice closeup.

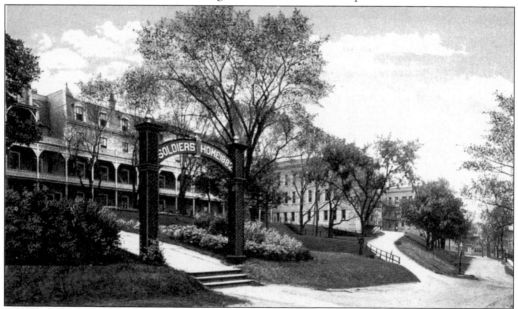

**THE SOLDIERS' HOME ENTRANCE.** The Victorian archway graces the back entrance on Hillside Avenue *c.* 1921. The original hospital building is behind the archway in the left background, and the Adams Building is on the right. Inscribed on the wooden archway is 1882, the year the Soldiers' Home was opened. At the ceremony, Gen. James A. Cunningham, a colonel in the Civil War, was appointed first superintendent and his wife, matron.

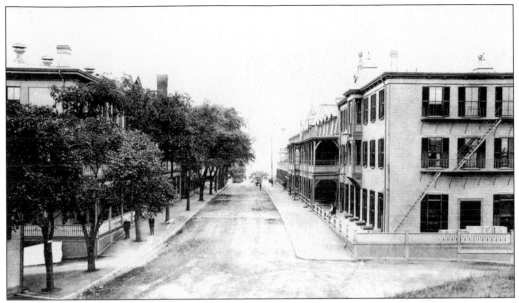

**THE MAIN BUILDINGS AND DRIVEWAY.** This *c.* 1920 eastward view of Crest Avenue shows Sargent's Hall on the left and, encircling it, a wraparound veranda, mostly obscured by trees. The feature has since been removed. The top of the power plant smokestack is visible above the trees. Across the street are the old Soldiers' Home and a hospital annex. The Adams Hospital, out of view, is to the left of the old home.

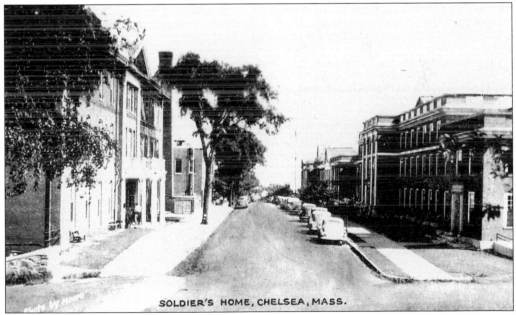

SOLDIER'S HOME, CHELSEA, MASS.

**THE SOLDIERS' HOME.** Taken 30 years after the previous view, the image shows the progress made in replacing the wooden structures on Powderhorn Hill with brick. A comparison of views also shows that Sargent's Hall (left) was updated: a decorative white portico was added, and the wraparound porch was removed. In addition, many shade trees were lost along the main driveway, likely victims of the hurricane of 1938, which hit eastern Massachusetts hard.

103

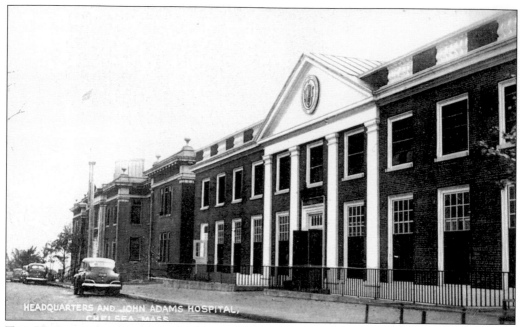

**THE HEADQUARTERS AND JOHN ADAMS HOSPITAL.** The Adams Building appears on the left and the headquarters building on the right in this *c.* 1950 view. The latter structure was dedicated in 1932. A chapel named for Capt. Joseph McCabe was located here. McCabe served as secretary of the board of trustees for many years.

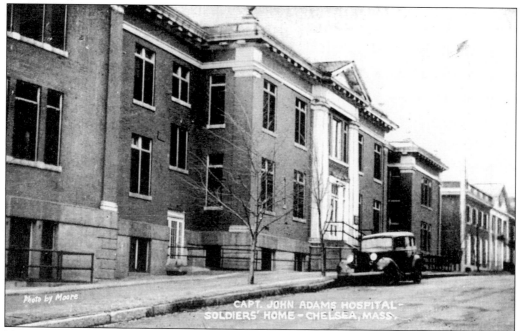

**THE CAPT. JOHN ADAMS HOSPITAL.** The Adams Hospital was located on the site of the superintendent's house. Built in 1897, it was moved across the street when the Adams Building was built, in 1908. Today, it is known as the commandant's house. To the right is the headquarters of the Soldiers' Home.

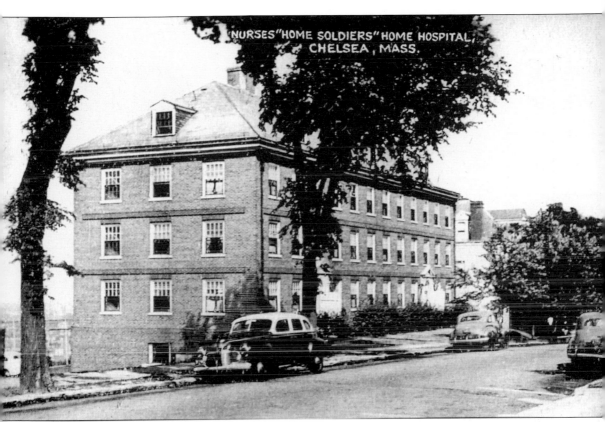

**THE NURSES' HOME**. Built in 1929, this brick structure served as a home for nurses at the time the photograph was taken, *c.* 1950. It was located across from the headquarters building on Crest Avenue. Today, it functions as a dormitory for veterans.

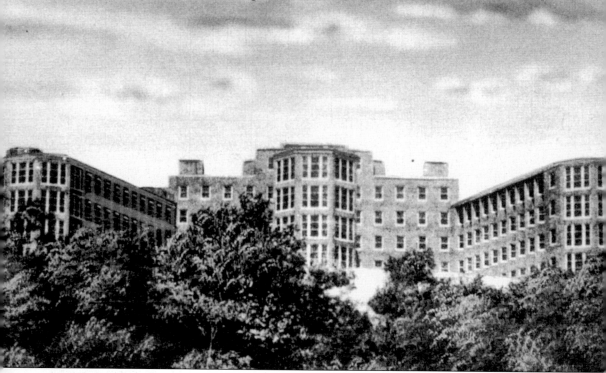

*Lawrence F. Quigley Memorial Hospital, Chelsea, Mass.*

**THE LAWRENCE F. QUIGLEY MEMORIAL HOSPITAL.** The 300-bed hospital was built opposite the Soldiers' Home in 1950. It was named for Lawrence F. Quigley, the first commandant of the Soldiers' Home and the former six-term mayor of the city. Quigley was appointed commandant after the state assumed management of the Soldiers' Home in 1934. Following his death, Quigley was succeeded by his son John Quigley.

**THE ADMINISTRATION BUILDING.** This *c.* 1961 postcard shows the headquarters building and the 200-bed dormitory for Massachusetts veterans of all wars. On December 1, 1934, the Soldiers' Home was assigned to the commonwealth of Massachusetts. A board of seven members was established to direct the home. Appointments were to be made by the governor and approved by the governor's council. Each member served a seven-year term.

**THE JOHN ADAMS BUILDING.** Seen here is the updated façade of the 1908 building, which provided dormitory housing for 225 veterans of all wars. John G. B. Adams was one of 18 men incorporated as trustees of the Soldiers' Home in 1877. Adams was not only a solicitor of funding, as previously stated, but also involved in the early decision of where to locate the Soldiers' Home.

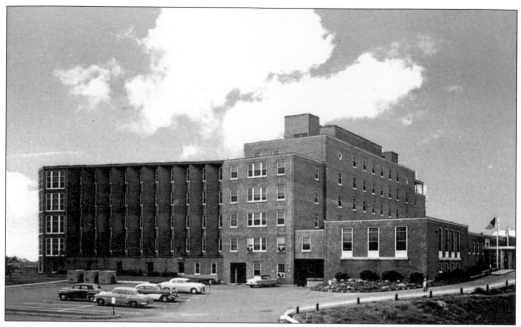

**QUIGLEY MEMORIAL HOSPITAL.** This side view shows the 300-bed general medical and surgical hospital in the early 1960s. Other than the old cars in the parking lot, the scene has not dramatically changed in the past 40 years.

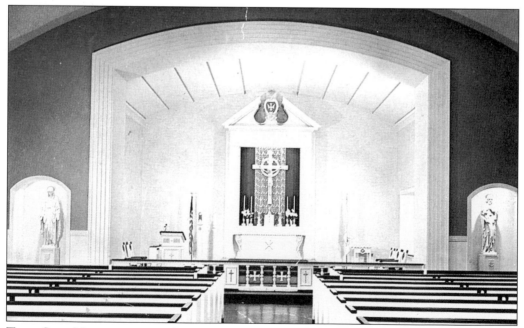

**THE ST. MICHAEL THE ARCHANGEL CHAPEL.** Three major religions—Catholicism, Protestantism, and Judaism—were, and still are, represented at the Soldiers' Home. This *c.* 1961 interior view of the Catholic chapel was taken shortly after it was built under the direction of Cardinal Richard Cushing.

# Eight
# THE 1940S TO THE 1960S

Few companies published postcards during this period. In the early 1940s, World War II was under way on several continents. The war effort was a huge undertaking, requiring vast amounts of human and material resources. Many raw materials, including paper and various chemicals, were rationed. Furthermore, there was little leisure time for taking photographs or producing postcards. Thus, compared to the early decades of the 20th century, fewer cards of less variety were manufactured. The author has not examined any postcards made during the war years. The included views date from the late 1940s to the early 1950s and reflect the austere times following the end of World War II, with their monotone colors and stark backgrounds. Nonetheless, the postcards are historically significant, as they document the changing times.

Most postcards of Chelsea published between the 1940s and the 1960s were of two types: photographic prints and chrome (high-gloss finish). Postcards made from linen paper were also a popular format in the early to mid-1950s; however, very few of Chelsea were produced.

The most significant photographer of this time was Roland A. Moore of Weston. Included in this volume are 10 different postcards views, likely half his output. These cards were produced c. 1950 and were published by the Collotype Company of Elizabeth, New Jersey, and New York. Printed in black-and-white, they show scenes not typically photographed. Included are Union Park, a city panorama, city hall, American Legion Post 34, the Soldiers' Home, and two churches. Moore is known to have taken at least one view of Chelsea Stadium and some of the other parks. The print quality is very good.

The American Art Post Company of Brookline manufactured a Photolux (photograph-type trade name) card of the new Mystic River Bridge c. 1953, offered in black-and-white or color. Herbert M. Siegel produced a small series of chrome postcards of the city, including the M. J. Tobin Memorial Bridge, a multi scene card, the St. Rose School, Church, and Rectory, and Prattville. All date from 1961 or 1962.

Moore and Siegel were the photographic historians of the post–World War II era, and their efforts have contributed to a better understanding of this period.

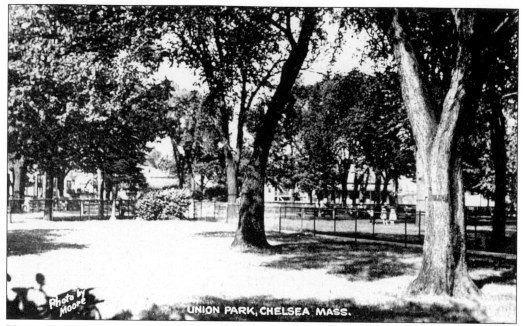

**UNION PARK.** Following World War II, temporary veteran housing was built on the Sixth and Walnut Street side of Union Park to accommodate the influx of returning soldiers. The units were later closed and converted to housing for senior citizens. In the late 1940s, the construction of the Mystic River Bridge resulted in the placement of supports on the park grounds. Both occurrences had a negative impact on Union Park and contributed to its eventual demise.

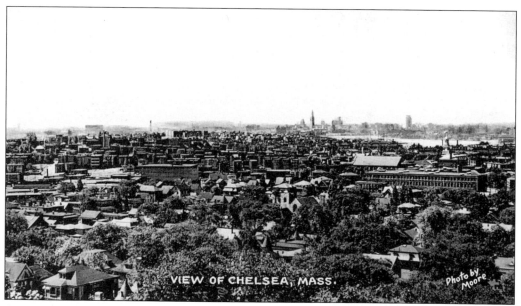

**A VIEW OF CHELSEA.** Taken from Powderhorn Hill, this *c.* 1950 panoramic view looks toward downtown Chelsea and Boston. Clearly visible on the left are the triple-decker houses that populated the side streets off Broadway. On the horizon is the Boston Custom House tower. To the right, one can see the roof of the St. Rose Church and the distinct clock tower of city hall.

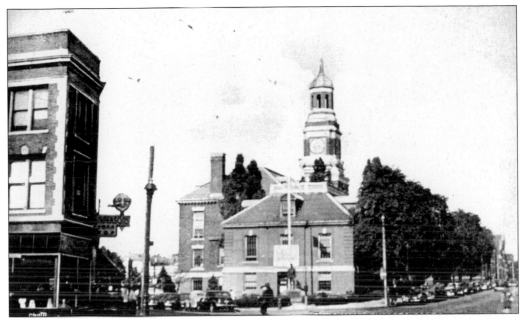

**CITY HALL.** This *c.* 1950 side view of city hall was taken from Bellingham Square. The square was named for Gov. Richard Bellingham, an early landowner in Chelsea who built a hunting lodge in 1659. After his death, the property passed through a couple of hands until landing in the possession of the Cary family. Modified a bit over the years, it was named the Bellingham-Cary House after its two principal owners.

**AMERICAN LEGION POST 34.** Located on Shurtleff Street between Grove and Marlborough, Post 34, seen here *c.* 1950, was a popular meeting place for veterans. The Soldiers' Monument can also be seen in Bassett Square. Other than the old automobiles in view, the scene is no different today.

**ST. LUKE'S EPISCOPAL CHURCH.** Hon. Albert Bosson (1853–1926) deeded the land at Washington Avenue and Silk and Spruce Streets for the construction of a new church to replace the aging structure on Hawthorn Street. The new church was dedicated in 1907. In 1924, a stained-glass window in memory of Samuel Maverick, the first European settler in Chelsea, was raised for the 300th anniversary of the settling of Chelsea. In this *c.* 1950 postcard view, Patrolman Wilson is on duty near the church.

**THE FIRST CHURCH OF CHRIST, SCIENTIST.** This Roland A. Moore view shows the church located at the corner of Cary Avenue and Tudor Street *c.* 1950. The building still exists, currently serving a Spanish Pentecostal congregation.

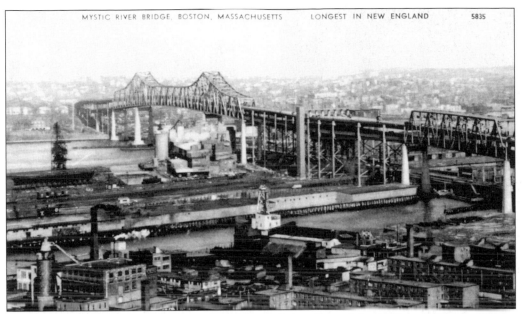

**THE MYSTIC RIVER BRIDGE.** A special commission formed in 1933 to study a plan for reconstructing the Chelsea North Bridge. The commission recommended that the antiquated drawbridge be replaced with a high-level bridge connecting Boston and Route 1 North. The proposal did not go forward due to the harsh economic times of the Depression. Finally, in 1946, the Post-War Highway Committee, under Sen. Edward W. Staves, succeeded in obtaining sufficient funding for building a bridge.

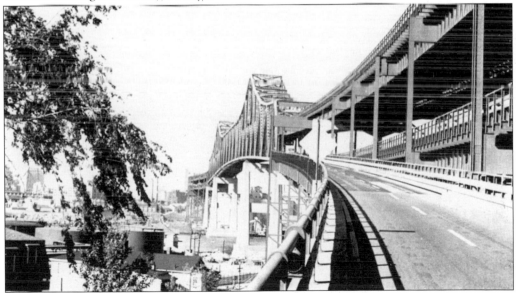

**THE MYSTIC RIVER BRIDGE.** By the late 1940s, bridge construction was well under way. On February 25, 1950, history was made as the Mystic River Bridge was opened for car traffic. Attending the ribbon-cutting ceremony were Paul A. Dever, governor of Massachusetts; Thomas S. Lane, commissioner; John B. Hynes, mayor of Boston; and William F. Hurley, president of the Boston City Council. The bridge's name was later changed to the Maurice J. Tobin Memorial Bridge.

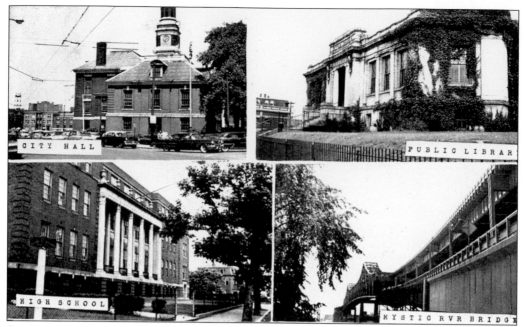

SCENES OF CHELSEA. Pictured here *c.* 1961 are, clockwise from the top left, city hall in Bellingham Square, with the Soldiers' Home water tower in the background; the public library, covered in ivy; the Mystic River Bridge, with one of the Chelsea off-ramps; and the Chelsea High School, on Clark Avenue. As of this writing, all landmarks are standing and serving in the same capacity except for the high school, which has since been converted to a middle school.

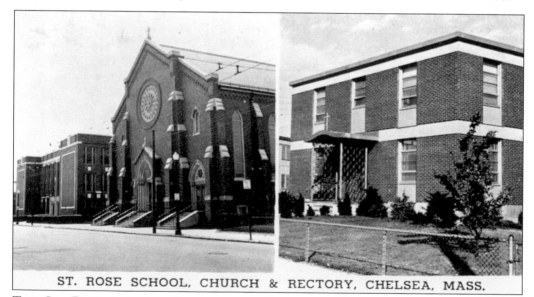

THE ST. ROSE SCHOOL, CHURCH, AND RECTORY. This *c.* 1961 multi-scene postcard shows the St. Rose School and Church on the left and the rectory on the right. The school was also constructed after the 1908 fire. In 1987, the girls' high school was closed; however, the school is still in operation, educating children in kindergarten through eighth grade. Today, the church still serves the immigrant community, offering Masses in English, Spanish, Cambodian, and Vietnamese.

# Nine
# MISCELLANEOUS VIEWS

This last chapter rounds out the book with a small group of various images, all which have a Chelsea connection. Most were taken in the city and date from 1870 to 1950. Some of the views could have been added to previous chapters, but the decision was made to limit the chapter lengths. It was not always easy deciding which pictures to use, but the author feels confident that the reader will enjoy the selection.

Several additional stereoviews were included to show the scope of Oliver F. Baxter's work. Two of the three were taken in nearby Saugus. Classified as scenics, or landscape views, they give a glimpse of how undeveloped the area was 134 years ago.

The remaining views are postcards by various makers. They include Broadway Square, the Cary House, the old city hall (likely by George F. Slade Jr.), two early orchestras, the Powderhorn Hill stairway, the Garden Cemetery, and Chelsea High School.

It is hoped that the included images will bring out the historian in all of us. Further research will undoubtedly uncover new views and information that will expand our knowledge of Chelsea's past.

**THE MILL STREAM, NORTH SAUGUS.** This stereoview by O. F. Baxter of Chelsea dates from c. 1870. Here, an old wooden bridge crosses over the Mill Stream. Saugus was not as easy a journey in 1870 as it is today. Remember that there was no Route 1, requiring travel over unpaved, rutted roads. These factors made travel laborious at best, even for those few short miles. Furthermore, photographers in those days had to transport bulky camera equipment on their excursions. This fact makes one appreciate the effort that went into making these images.

**A ROADSIDE STUDY, SAUGUS.** O. F. Baxter took this negative either on his trip to Saugus or on his return to Chelsea. The significance of the subject is unknown. The storage units of some sort (mounds) appear to be made of saltwater marsh grass or hay. One possible explanation is that the grass was once harvested from area marshes, possibly Rumney Marsh, and used as building material on local farms.

**THE WOODLAWN CEMETERY.** O. F. Baxter published at least four images of the Woodlawn Cemetery (see page 10). Here, a rustic arch appears on Woodside Avenue *c.* 1870. In 1850, when the cemetery was incorporated, traveling to it was an adventure. An 1854 Chelsea directory advertised the Woodlawn Cemetery as a major stop of omnibus service from the Chelsea Ferry, two miles away via hilly roads. The hills could be avoided if one traveled Malden Road instead of Washington Avenue.

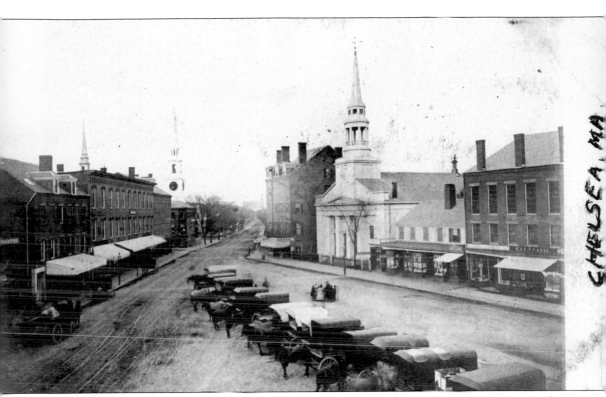

CHELSEA, MA

**BROADWAY SQUARE.** This 1866 view, looking up Broadway, was issued as a postcard c. 1905. It appears to be Market Day, as the horse-drawn wagons are neatly lined up in the square. Four churches are visible in the scene. The Broadway Congregational Church is the white building on the right. The postcard was likely a memento of what life was like in the "old days" 40 years earlier.

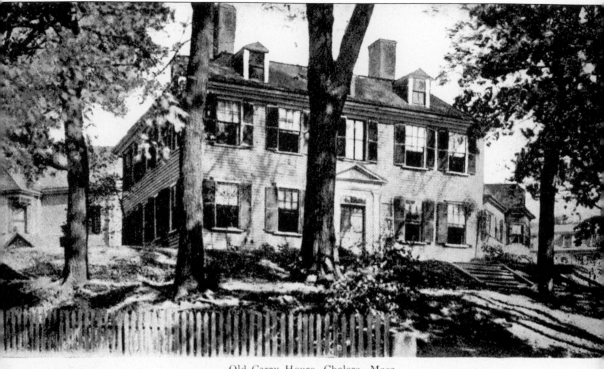

Old Carey House, Chelsea, Mass.

**THE BELLINGHAM-CARY HOUSE.** The oldest house in Chelsea is pictured here in 1905. Originally built in 1659 by Richard Bellingham as a hunting lodge, it was later modified into a mansion in the early 1700s. The house and farm passed through several hands before coming into the possession of Capt. Samuel and Margaret Cary. Their children and grandchildren continued ties to the property. The last Cary to occupy the house died in 1881. In 1908, the house was purchased by the Bellingham-Cary House Association. The group still manages the property, which can be visited at 34 Parker Street.

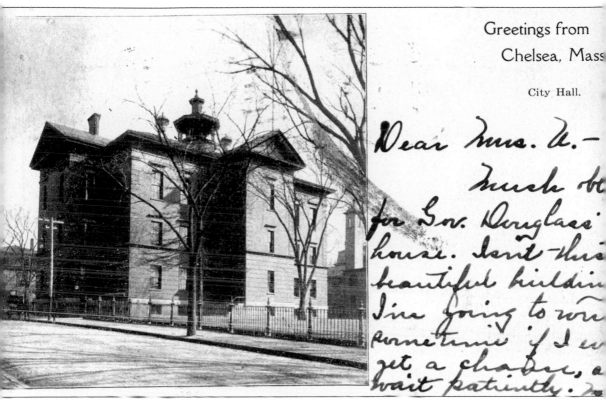

Greetings from
Chelsea, Mass

City Hall.

Dear Mrs. A. —
much be
for Gov. Douglass'
house. Isn't this
beautiful buildin
I'm going to wri
sometime if I ev
get a chance, a
wait patiently. ↗

GREETINGS FROM CHELSEA. Although there is no credit to the photographer, this *c.* 1905 city hall view was most likely taken by George F. Slade Jr. He published a small series of postcards of the city, with and without the printed logo "Greeting from Chelsea, Mass." The amount of postcards Slade published is not known; however, there could be as many as 50 views. He produced some of the earliest picture postcards of the city.

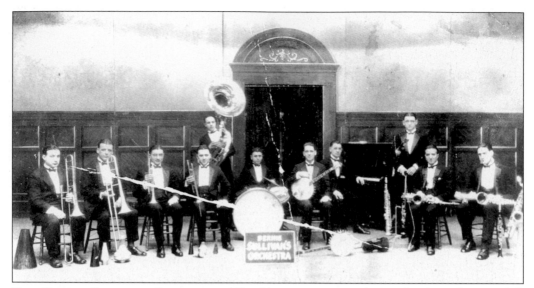

**THE BERNIE SULLIVAN ORCHESTRA.** On this page are two views of early orchestras with Chelsea connections. Although not much is known about these images, they were taken no later than 1910. This card, marked "Chelsea, Mass." on the reverse, shows an all-male group of musicians. Bernie Sullivan holds the banjo.

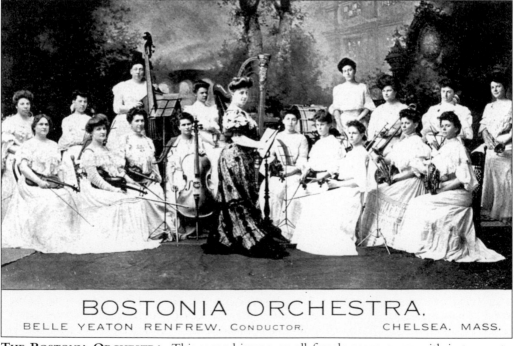

BOSTONIA ORCHESTRA.
BELLE YEATON RENFREW. Conductor.        CHELSEA. MASS.

**THE BOSTONIA ORCHESTRA.** This second image, an all-female group poses with instruments. The title identifies the conductor as Belle Yeaton Renfrew of Chelsea, the matronly dressed woman standing in the middle.

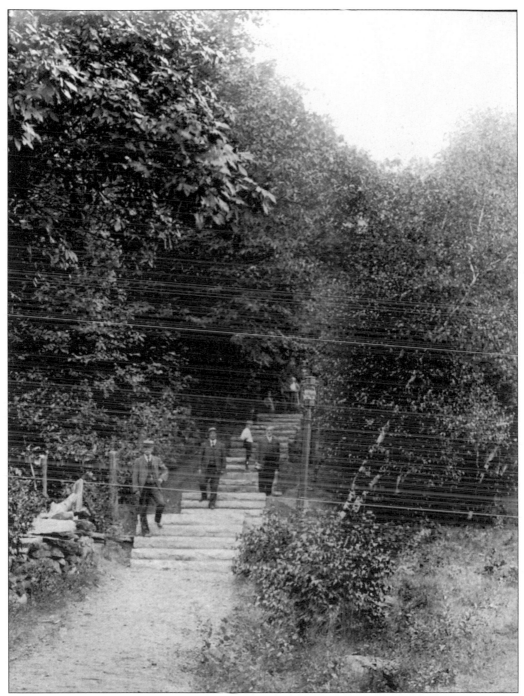

**THE STAIRWAY TO POWDERHORN HILL.** Powderhorn Hill was the tallest elevation in the city, at 230 feet above sea level. The message on the postcard's reverse describes the pictured group's recent trip using the new approach to the campground. This image has a Chelsea postmark and is likely an early view of the stairway that provided a means of connecting the base of Powderhorn Hill, at the end of Gardner Street, with the summit on Hillside Avenue. A more modern version of the stairway still exists today.

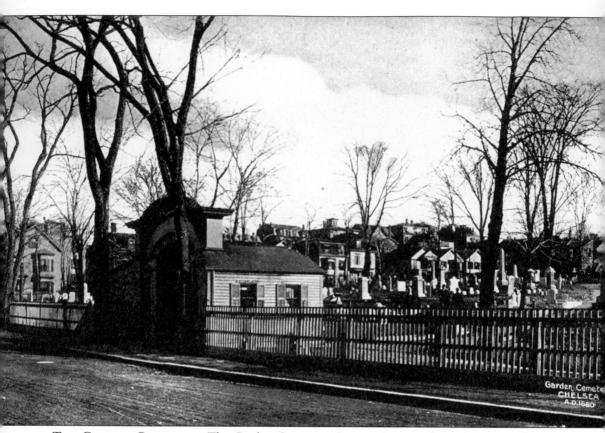

Garden Cemete
CHELSEA
A.D.1680

**THE GARDEN CEMETERY.** The Garden Cemetery Corporation was formed in 1841 after city leaders determined that a new cemetery was needed to accommodate the population growth in Chelsea Village. At the time, the nearest cemetery for local residents was the Rumney Marsh Burial Ground in Revere, because the Woodlawn Cemetery had not yet been built. After several land proposals were found to be unsuitable, the Garden Cemetery Corporation chose the Winnisimmet Academy land, bounded by Central Avenue, Shawmut Street, Chester Avenue, and the Winnisimmet Company property. The cemetery was dedicated on November 4, 1841. The city of Chelsea took over operation of the cemetery in 1905.

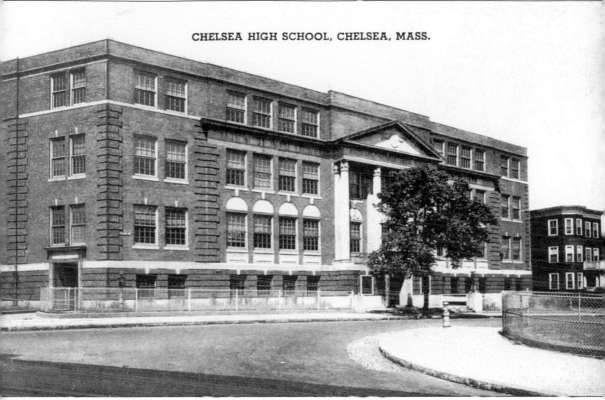

CHELSEA HIGH SCHOOL, CHELSEA, MASS.

**THE CHELSEA HIGH SCHOOL.** A large addition was added to the school in 1926, extending the school from Clark Avenue to Tudor Street. This printed postcard, likely by Roland A Moore, dates from *c*. 1950. The building now houses the Clark Middle School.

# BIBLIOGRAPHY

Adams, Capt. John G. B. *The Massachusetts Soldiers Home,* 1890.

Bauer, K. Jack. *United States Navy and Marine Corps Bases, Domestic.* Greenwood Press, 1985.

Chelsea Police Journal, 1908.

*Chelsea Record, Hospital Edition,* May 13, 1977.

Clarke, Margaret Harriman. *Chelsea.* Charleston, South Carolina: Arcadia Publishing, 1998.

Gillespie, Charles B. "The City of Chelsea Illustrated." Chelsea, Massachusetts: *Chelsea Gazette,* 1898.

Hegen, Elizabeth Durfee. *Life Everlasting.* Chelsea, Massachusetts: Woodlawn Cemetery Corporation, 2001.

Old Suffolk Chapter: Sons of the American Revolution. *The Battle of Chelsea, 27 May, 1775.* Boston: Press of Wallace Spooner, 1901.

Ostler, George and Mary M. Bourque. *An Abridged History of Chelsea,* 1994.

Pratt, Walter Merriam. *The Burning of Chelsea.* Boston: Sampson Publishing Company, 1908.

Pratt, Walter Merriam. *Seven Generations: A Story of Prattville and Chelsea.* Privately published, 1930.

Scanlon, Jack. "Erection of Mystic River $27,000,000 High-Level Bridge Hits High Gear." *New England Construction,* December 1948.

Snow, Edward Rowe. *True Tales and Curious Legends.* New York: Dodd, Mead, and Company, 1969.

Waldsmith, John. *Stereo Views, An Illustrated History & Price Guide.* 2nd edition. Iola, Wisconsin: Krause Publications, 2002.

# INDEX